San Diego Poetry Annual
2010-11

The Best Poems From Every Corner Of The Region

PUBLISHER
WILLIAM HARRY HARDING

REGIONAL EDITORS
BRANDON CESMAT
OLGA GARCÍA
EDITH JONSSON-DEVILLERS
SERETTA MARTIN
ROBT O'SULLIVAN SCHLEITH
TERRY SPOHN
MEGAN WEBSTER
JON WESICK

authorHOUSE®

AuthorHouse™
1663 Liberty Drive
Bloomington, IN 47403
www.authorhouse.com
Phone: 1-800-839-8640

First published by AuthorHouse 4/8/2011

ISBN: 978-1-4567-4142-6 (e)
ISBN: 978-1-4567-4143-3 (sc)

TABLE OF CONTENTS

FEATURED POET

STEVE KOWIT

Poetry Without Borders

Poesía Sin Fronteras

Contributors

Publisher's Note

As the **San Diego Poetry Annual 2010-11**, our fifth in the series, goes to press, the shooting of Congresswoman Gabrielle Giffords and others in Tucson dominates the news. Sam Hamod's *Tucson* leads off this edition with a reflection of a different time in that city. Poetry and art anchor our understanding of the moment with a context of history lived and a future promised.

With 154 poets and 235 poems, this is our most diverse and wide-ranging annual yet. Credit goes to the Regional Editors, who selected and edited each poem. While this edition, like our others, belongs to the poets, it also belongs to the Regional Editors for making sure the best poems from every corner of the San Diego region found their way to these pages. The work of celebrated literary giants joins poems from contributors of every echelon, including some who are published here for the first time.

The Bilingual Section, featuring the work of 36 poets, continues our tradition of celebrating diversity and excellence. The editors of this section asked to acknowledge Vicky Nizri for her help this year.

Our Featured Poet, Steve Kowit, has long been one of the treasures of San Diego. His four new poems make their debut in this edition.

Copies of the 2010-11 annual will be donated in the name of the contributing poets to college and public libraries throughout our region. Distribution of the copies will be completed by the summer.

– William Harry Harding

THE POEMS

2010-11

GARDEN OAK PRESS
RAINBOW, CALIFORNIA

sandiegopoetryannual.com
gardenoakpress@earthlink.net

This edition of the **San Diego Poetry Annual**,
along with our previous four editions,
is available at authorhouse.com,
amazon.com and barnesandnoble.com

SAM HAMOD

Tucson

– in memory of Tucson, dead and dying in the 70's

cracked leather dashboard,
door handles burn
blisters on my hands,
in the afternoon 115 degree sun,
Suharo standing stiff,
dried out
in the endless sandy plain,
my '73 Barracuda
not fit for this devilish place
where people
their souls ghost white,
say they love the desert,
going out in their air-conditioned
Cadillacs from Omaha, Des Moines, points east,
stare at the desert all afternoon, but
the Papago know
no one loves the desert
except Fools,
they were captured in Santa Rosa
by the cavalry before they could take their sheep
back up north for the summer, so now
they sit, looking like their Eskimo cousins, out of
place in these wooden,
uninsulated government
houses, with no way to escape
this heat – but today, in an old adobe, I sit
talking quietly with the medicine man, have
warm bread, some meat, knowing neither of us

is crazy, that what we know of
Iowa, Wisconsin, and northern Arizona more of heaven
than this place closer to hell than most,
understanding why so many
gunfights took place in the hot Tucson sun,
why so many Papago went crazy or drunk,
with no sense of time or place – he understood
that when the coldness of death came
for me, I willed against it, otherwise
in that dark room on Country Club Lane
in November 1974, death would have taken me,
but in this cool place, thick adobe walls
and fresh water, our eyes know one another's
hearts, and though the Papago are trapped, they
know they will survive,
but they tell me
to go, to get away, go back to green
and water, where trees speak of winds
and river fish will tell you of deeper water,
and the women have bodies that are warm
and willing because they know love
not the desert's hollow death rattle, and
leave those behind
who live in the myth of this place
as if it is a sanctuary, but is
in reality, a stifling trap that few escape
it is an ending place, not a place to start from, and no
matter how many decorations or piñatas
they explode, there will never really be joy
in this desolate dry unforgiving desert

DENISE ROUFFAER

The Change We Don't See

Open us up–

That we may have
The same heart–
A heart of gold
A heart of steel
A heart so pure
It won't seem real.

Yet, it's as real
As a flower
And it can bleed.
A heart of love
Is simply
What we need.

MICHAEL BURTON

A Mirror Reflecting Mirror A

The Writer locked in his bedroom
The Manuscript is almost finished, soon
The Writer will whore himself out for bread.
All that is needed is an ending.
The Writer thinks and sighs, utterly spent.
And becomes aware of a presence in the room.
It is 4:05 a.m.

The Writer turns and sees nothing.
The hairs on the back of his neck prickle
and he shivers. The Manuscript can wait. Caffeine will stave off
the sleep and the fictional presence. He gets up
and unlocks the door, heads to the kitchen.

The kitchen is quiet, the snap of a Fanta
opening with a violent hiss an unwelcome disruption.
The Writer knows the presence is there
but refuses to acknowledge
its intentions. The presence waits impatiently
aware of a deadline.
It is 4:11 a.m.

The Writer heads back to The Manuscript but cannot think of an
ending.
The presence denies him one until
The Writer gives in.
He grows agitated. His existence hinging
on the moment. The Writer stands.
It is 4:13 a.m.

The Writer mutters a challenge the presence
cannot answer
The Writer shouts an insult
the presence does not understand
The Writer knows
I CAN SEE YOU
ON YOUR GODDAMN PEDESTAL
THE THRONE OF PAIN AND PROFIT
the presence laughs softly
The Writer's blood drains from his face.
It is 4:17 a.m.

I WILL NOT OBEY
The Writer runs to the kitchen
the presence is already there.
The Writer grabs a kitchen knife
And jams it in his stomach.
Twists.
It is 4:18 a.m.

Before The Writer dies
His blood pooling on the floor
His last thought is that of freedom
and satisfaction at an ending.
The presence nods, content,
leaning back in his chair, casting a shadow
in the glow of his laptop. He turns it off
And becomes aware of a presence in the room.
It is 4:05 a.m.

KAYLA KRUT

Your Hands in Los Angeles

If your hands are soft spindly branches,
mine are blades lined with bronze.
Thin as light,
this hallway lives for dropped calls –
Halfway through your violence
on San Fernando summers, I lose you –

Elsewhere, damp air settles infinite and birdlike,
cupfuls of sweat on my pillow, my unmade bed
at inexplicable rest.
 I have not lost you,
the damp air opens its white eyes to say. . .

In my striving I have disregarded the time
spanned by these calls –
Like lullabies, you said sirens were,
and as kids you and your brothers slept
naked with no sheets, ice water at the window,
traffic on its hot and weary beat –
 Tension must be equal on both sides, you said,
taking comfort in my striving (such striving!) –

Two voices surface from the stairwell, one
a cold gray whisper, the other raised –
Those lovers can at least blink eye to eye.

My fingers have long been sculpted and involved,
adamantine refusals in a slim book of ten.
Your hands are as suffused brightness:
lights from the pier spasm across the Pacific,
wide softened crystals of primary colors –
Maybe now is not the time to move
forward with the restive torso of this Eden.
These mail-order flowers fail in daylight
as they never should fail.
 They'd wilt in the goddamn Valley anyway.

I have been one struck dumb by mornings
fresh and cool in their veils of long-distance:
 Hands red from overwork, those I can understand –
 hands hyperextended by worry, those I can grasp –
But hands dark, wiry, strong, that don't need me,
fingers like skylines, each supple as a tree branch –
I am so much more calm when the delusion
of an equal tension holds: when it is
harmless to end a phone call, to choose not to doubt.

WAYNE HOSAKA

Motorcycle on the Golden Road

I was on the Golden Road
All of my labors were being rewarded.
I was beginning to grow out of the shadow of doubts
that had been with me since I left the security of childhood
and entered the adolescent jungle.
I was 21 and on top of the world.
I was 22 and reaping the harvests of the young man.
I was 23 and crashed to earth as Icarus
into the shadow of Sisyphus.
And I want to be set free
to be enlightened.
Maybe the next
will be the last.
Maybe the next
will be the best.
So I toil
willingly!

MICHAEL L. EVANS

O Brother, Can You Hear Me?

– for LLOYD WAYNE EVANS, brother: 1950 - 1987

Somewhere,
the bugles of Agent Orange
are playing Taps again –
somewhere, my rage
echoes

POLINA BARSKOVA

Motherhood and Childhood

– Another reflection from Prague, by the grave of NABOKOV's mother

Not far from where Dr. Kafka lives in the earth
Where I expected souvenirs and tourists
Is an empty space, a bench, trees.
I will sit down; sit, then walk.
Walk to the left to the right straight.
A tired cross, a bored little cat, a hole in the earth.
Sergeant so-and-so, Averchenko – and here,
Mother of the one we both love,
One who moistened thoughts, veiled with smoke
The boring truth about days (that they rot).
Here, on the far end of Prague, alone, poor girl, his mother.
And the gravestone over her is a confused dirty rock.
And a homeless cat sits on it, scratching its white belly.
And not far, with a magisterial noise Prague moos.
She lives here in Prague's soil, under wet pines, his mother
Who washed him in the basin with a cup of water, and sang.
In the darkness her body was leaving, trembling, in flight.
And he a lump of flesh in her hands –
A lump of flesh, her heat, a home.
But for years her scent, and years later, her scent.
And her clarity, and doubt, and her whispers –
Like every love, in the end, she bored him.
Nothing there.
She was dying alone – he could not visit;
At the table in his reading glasses, he sat.
The cat darkly dug into the smallness of a caught bird.
The bird's cooling eye stuck straight.
And he was told: In Prague, Mama died.

He lies naked on something white,
She laughs above
She covers him
With her pearl, her body her
Star, her body her snow, her body
On top of the word "strange,"
On top of the word "fright."

– translated by KATHRYN FARRIS and ILYA KAMINSKY

JANET FOSTER

This Poem

I am not thinking about him.
I am not writing about him.
This poem is not a poem
about him.

My insides are shiny
metal spoons
clicking against one another,
smooth round backs with
curves inward
like a welcoming embrace.

My insides are silver spoons—
rusty metal,
barely bendable.

I am not thinking about him.
I am not writing about him.
These words speak of everything
but him.
My mind is a fence,

made of mesh wire,
catching thoughts
before they can climb over the top of it.
Caught like the tail of your shirt
on barbed points–
my thoughts

are not about him.
They fly out from
the barbed wire
like a kite
threatening to escape its string.

My heart is a cavern
and inside that cavern
is another cavern,
like a doll within a doll–many
smaller versions until
you reach the final one,
with its small face,
rosy cheeks–so small
you could carry it around
with you

or drop it–falling through
the hole in your pants pocket,
the hole in your heart.

JOHN WEBB

She wanted to know, "What's love for you?"

Love is the wedding of world and song
in the human heart. In the presence of the
beloved, the melody rises, and images of
all we'd ever dreamed appear before us.
 We become young again.

TOMÁS GAYTON

A Letter from Lili

Today another letter arrived from Lili
Postmarked a month ago
She sends me *besos y abrazos*
from Santiago
Each letter a life line to freedom
from her daily ration
of black beans and rice
and party propaganda

With each missive
she sends me a flower
that keeps hope alive
in the belly of the beast
that torments and taunts her
for living on the forbidden island
with the defiant bearded one

MAI LON GITTELSOHN

Chinatown – Yesterday, Today

How to describe the Chinatown of my youth
captured as it is in the mind of a child
who cannot control where or when to go
but can only hold onto her mother's hand
or stumble after her sisters, who are wearing
too much make-up, her father striding ahead
while her mother follows, almost
at his side.

Roast ducks hang by their trussed legs
in the window of the poultry shop, eyes
like slits, oval nostrils in the beak dark
craters on the moon, the bronzed skin
dripping fat.

Fog horns bleat as mist settles gently
around our shoulders; I feel the press
of bodies, families with children, gray-haired ladies
carrying oranges in string bags, lips clamped tight
after a day at the sewing factory pushing fabric
under the wicked flash of needles.

Everywhere the lonely Chinese bachelor
reading the Chinese newspaper
on the corner of Grant and Stockton.
In the window of Uncle H's coffee shop,
sipping coffee with a slab of apple pie.
Climbing four flights of narrow steps
to swallow rice porridge at night, letting the soup
bland and gelatinous, slide down his throat
sore from too many cigarettes.

Today, a visit to Chinatown is a trip to Hollywood –
desperate hostesses dressed in silk
stand in doorways waving menus.
Come in! Come in!
Try our authentic Chinese food. No Chop Suey.
Tourists find plastic toys made in Vietnam
while I keep looking for my past
past the stone lions guarding the gateway
to a deserted Grant Avenue.

KENNEDY GAMMAGE

32° N 117° W

Early Autumn Keatsian warm hazy sunlight
*Late for the Sky*ish drowsy afternoon
Magritte blue with pure white clouds.
Purple and white Mexican Salvia blossoms
bend languidly, quivering as the hummingbirds feed,
wings a buzzing blur, powered by their
diminutive living motors. I love the birds
but am wary of the bees
particularly this enormous bumblebee
precisely because it hardly buzzes.
It's the size of my thumbnail, rich and glossy black
heavy enough so that each time it lands
it tugs the Salvia down like a straphanger tugs the bell-pull.
A squawking fills the sky – the parrots!
The wild Mexican Red Crowned parrots
kicking up a bright green ruckus
with their powerful wings and voices
in their agitated haste to reach the coast.

spiky red high-heeled shoes

rolled out of my bed that morning
determined to beat my blues
slid into stockings,
a come-hither dress
and some spiky red high-heeled shoes
three inches high
Italian leather
show of my stems for your viewing pleasure
I got eight miles of leg
there's no way I can lose
in these spiky red high-heeled shoes
the weather was lovely that morning
the world was a wonderful place
so I moseyed on over to your side of town
to look at your beautiful face
see I thought I'd surprise you that morning –
slip on in and help warm up your bed
I had no way to know how the tables would turn
and I'd be the surprised one instead
six inches high and constructed to flirt
and so hot that I don't give a damn if they hurt
I got eight miles of leg
there's no way I can lose
in these spiky red high-heeled shoes
slid into your bedroom that morning
and boldly pulled back your covers
and I can't imagine the look on my face
as I saw you there with your new lover

well, pain makes unpleasant decisions
but I know that it doesn't excuse
and I'm sure I'll regret for the rest of my days
how I beat her to death with my spiky red shoes
six inches high
and lethally sweet
and more deadly by far in my hands than my feet
I got eight years to life
and I wish it was you
that I'd killed with my spiky red high-heeled shoes

<div align="right">Jason Lester</div>

Three Electric Haiku

I saw mournful stalks of wheat
making love—
two delicate curls

a man confided in whispers:
the Germans do something
unspeakable—
they slice up their verbs
and stick nouns between them.

a cormorant told me
when you shake someone's hand
you pass on an ecstasy

> Electric Haiku: A form of Contemporary American Haiku:
> a short poem that is evocative, enigmatic, open-ended or
> has deep resonance.

MARGE PIERCY

How big a space is needed?

When I was little, I'm told, I cried
entering tunnels. Those mouths
fed into narrow darkness, tight
as a worm's burrow. Who knew

if we would ever escape into light
or be digested there in that
black stomach? Recurring fear
of closed in spaces cramped

my childhood. Claustrophobia,
one of the first long words
I learned long before I could
read it. Our house was narrow

enough and I had no space
of my own. My bedroom, a
corridor with sewing machine
beside my bed. My bed, shared

half the year with my grandma.
Between my parents' tempers
a dance between two bonfires
a narrow wriggle of safety.

They call where I live *the narrow
land* but on either shore, the eye
swims out to a wet horizon,
sea huge under endless sky.

AL ZOLYNAS

Nothing To Do, Nowhere To Go

– after the T'Ang poets

At my feet, even the water spider
rests, unmoving on the still surface,
his eight feet dimpling the water's skin.

In the distance, on the other side,
a rowboat cradles a dozy fisherman.
The afternoon hums on the edge of sleep.

What should I be doing?
Surely work calls – chores, family?
The past is gone, the future

a dream of colors and light.
I'll take my cue from that mallard
nestled on the embankment,

head tucked under wing,
one eye barely open, tilted up
at the hawk-empty sky.

ANNE-MARIE RISHER DYTEWSKI

No Escape

Plagued by absence of hope,
descending like fog,
all visibility disguised.

Try to run, but it chases you,
takes control
weighing you down.
Sometimes freed from its clutches,
it's merely in remission, waiting to surface
again.
Pretend to be rid of it.
just an actor
putting on a performance.

It always happens the same way.
The paralyzing gloom, the nagging thought
that hounds me into its chasm.
The wrestling, the struggle to
restore my being.

Difficult to overcome,
but to stay in this void is to die a slow death.
The meaninglessness. . .the shrinking into nothingness,
the falling farther into darkness;
how like vapor I dissolve.

I've been here before,
dragging around this din
of misery – no escape
but to retreat into sleep. . .and safety;
pull up the blanket of protection.
Upon awakening,
nothing has changed.
O insidious irrelevance.

HARRY GRISWOLD

Spam With Banalities

My e-mails stream in,
pushing me
to back a cause, a vote,
to save the environment somehow,
to enroll in a social network
where doleful details
will forever flow. I just want
a simple indecent proposal
from someone hot
who's thinking of me –
not that I'm eager for
something I'll regret
in the morning,
no, I only want to swim
a few moments in fantasy
away from my regular life
in which my wife and I read the *Times*
half of every Sunday –
swim to where I can
write on a wild white
screen stretched naked before me
and begging to become
so much more than blank.

HOPE MEEK

Seven Days of Fog

Old rags in my trunk no longer fit,
and I am sick with age, and lack of wit.

DAHRYN BELL

To the Orange, Peach and Plum Trees

I wanted to do it this time.
I had seen my mother and my grandmother
do it all the time.
I figured that I was careful enough,
despite my age.

Grabbing his hand
I guided grandpa out into the backyard.
The ground was littered with
dead, colorful leaves
which I knew he couldn't see,
but I smiled to myself
as they crunched loudly under his
blind feet.

I led him to the orange, peach, and plum trees
lined up along the side of the house.
They were all bare
and stripped of leaves,
but I told him how the sun peaked through
the clouds above
and covered the trees
and branches in a golden glow.
He was smiling
and I'm sure he had been the entire time.
I had told him to wait,
that I would be right back,
real soon, too
And I ran inside
for God knows what.

Maybe I wanted to bring grandma out too,
and when I returned
to the orange, peach, and plum trees,
his forehead was colored with dripping red,
not too far from an old twisted branch
that hung right by his head,
and I screamed for my Grandma.

STEPHEN MCDONALD

Are You a Barnes and Noble Card Club Member?

A bud of anger quickened in that space
behind my chest where the liver cleanses

the blood and sends it on to the heart,
so I filled my lungs with a slow breath

and lowered my eyes because she was young
and sweet and asking what she was supposed

to ask, but when I said *No* and she continued
with what I was missing – ten percent off
every purchase, thirty dollars in coupons,
special discounts available only to members –

the old twisting of the large intestine returned,
and the constriction around the heart,
and the need to explain what I could not explain,
how a moth, disoriented, circles a light

in search of the moon, how Atropos, daughter
of Night, cuts the cloth that binds us to our lives,

how my father, now dead, still calls to me
in the dark of the morning, the grass wet,

the steeple of the church looming in the distance,
how I, at fifty-nine years of age, stand now

before this Virgin Mary, asking her to love me,
I who am not and never have been

a Barnes and Noble card club member.

C.A. LINDSAY

The Other Side of Fog

– inspired by Mission Gorge Rd.

How fog fades the mountain and
swallows the brutal gorge in white
haze: silent, blinding wall
that shades the truth until
sun melts the mocking mist
to let man know of light
and, maybe, even God
on the other side of fog.

FRED LONGWORTH

As I Return to a Memory of Linda

I discover it has worn smooth
from thirty years of handling.
It slides through my fingers
and falls on the floor.

I drop to my knees like a toddler
whose Oreo has slipped away
from saliva-slick hands,
and grub through cat hair,
flakes of human skin bits of bug
bodies tracked in from the yard.

Like the child, when I find
the treat I've dropped,
I couldn't care less about fragments
of leaded paint, or particles
of herbicide from the rose garden.
I pick it up as if I've just trekked
across some vast and lifeless
desert to the only oasis on the planet.
And this is my cup of water.

Don't Follow Me, I'm Lost

At nightfall when the sky turns the deepest blue,
it's soul-time, god-time, the lilacs of sunset
already drowned while I make a wrong turn.
Most poets have no sense of direction,
even if they don't cross themselves

before driving off into the so-called
"real world" – the moon elegantly wasted,
the four dogs in the back
of a rusty pick-up truck
in ecstasy, gulping the wind –

while I chronically don't know
where I am, why everywhere I go
I see artificial waterfalls
at the entrance to a shopping mall –
Soon I don't know who I am,

under which false name, or why I was ever
given the poetic license to drive.
And thus we are both lost,
I and America , under the ruinous moon,
abandoned as soon as it was "conquered."

We read again the torn, out-of-date map,
and pray, growing more religious
the darker it gets, under the illegible
signposts of the stars –
though the afterlife, once we're out of

the tunnel, will probably be another
crowded parking lot.
You say, why don't you ask for directions?
Sometimes I do, but mostly
I'm in the desert like Moses, for forty years

trying to find the Promised Land.
By now I believe that country exists
only in my mind, the kingdom that is within.
It's not darkness that blinds us, it's headlights.
Don't talk to me about the moral compass –

I need to be told how to get
to I-15, the long highway that leads
one way to the garishly lit
wilderness of sin, Las Vegas ,
where I was told, "It's not the winners

who pay the electric bill" –
The other way leads home, or, if I miss
my exit, to the edge of the world:
white roar of the Pacific
and the ever-eroding cliffs.

R.T. Sᴇᴅɢᴡɪᴄᴋ

Abundance

time is acting out again
this time
in the poppy bed

bent-over furred green buds
brilliant wide-open blooms
partially-petalled stalks
still proud and erect

isn't it strange how desire
fills the body
at awkward times of day

how we lower the bar
on morality
go guideless
into the river of life
like a noisy storm
three parts thunder
one part rain

then the sky stretches out
in powder blue pajamas
readies the bath
with indelible scent
of summer night
and lights its candles

abundance
to a certain degree
can be trusted

MARJORIE STAMM ROSENFELD

Flatlands

Give me the land of the child I am
which lay in front of me like a carpet,
 those flyaway nights. . .when I slept
 with my head on the lap of my father,
air breathing alfalfa, the tassels of corn
 waving to us outside the auto's windows.

I am not comfortable here in this muddle of hills
 which is San Diego. The hills. . .tell them
 to hunker down. Roll out
 the flatlands of childhood,
the fields drowsing in moon glow,
 signposts of stars hung in the sky
 like enormous sermons.

The stars turn from us.
 Universe . . .galaxies
 wheeling away
 at terrific speed.

This is more space than I wanted.

 I can hardly keep up.

Ginger, why did you have to die?

Gold fish in the toilet, rats beneath the agapanthus,
raccoons and Rosie the chicken, the old dog that disappears
and nobody asks where. Children need this, its training
for what's to come. Few really "go gently into the night."
It's usually smelly, lavender and urine, begging for deals,
terrifying for everyone and those left behind,
if they would admit it, are damn glad it's over. In 1923
a department store in Tokyo caught fire and dozens
of kimono shop girls died because they wouldn't jump.
Beneath the kimonos, tradition held, you wore nothing.
A city law passed soon after decreed that shop girls
wear panties. When father died, mother, Mother
who couldn't write a check or pick her dress for the day
without father, sold everything, put down his stupid poodle
and flew to Oaxaca, a spot her finger landed on.
It all became clear when the embassy called us to claim

the body.

Fifteen years ago I tattooed my back with a line from an e.e.
comings poem; "how do you like your blue eyed boy,

Mr. Death."

And each year I run faster, a glance over my shoulder,
the dark clouds growing, anvil shaped, tornados, typhoons.
I can shave every morning and not look at my face. Just
a peek so I don't nick the chin but not enough to see
my father's face looking back at me. Who is this guy?
Why are his lips so thin. And the spots on the cheeks,
the floppy ear lobes, weird sprouting hair; bags and sags.
Children need this. They really do. Whoever it is, sell
my stuff, go to Mexico, don't kill my dog.

JIHMYE COLLINS

A Citing: The New Paradigm

The footprints before me
were firmer than mine,
as if a calling to follow
two chariots drawn by a white horse
and a black one too

one lasering in the principle of *Justice*,
the other a zenith stream of virtues,
a guiding star from the 4-corners
illuminating the path for future generations

children on a road of Ahimsa
a de-Avatared abhorrence of violence
from Eli's Edge of Darkness,
caring to understand and appreciate differences
once grasped, a beauty to behold
if most of us, modeling for the children
imagine in concert, the morning
to be a new beginning

schools for the first time
designed with a singleness of purpose
an equality of resources,
no matter the neighborhood train tracks
youngsters putting into perspective
all the games of ball
through 3rd-grade readers
brer rabbit and little red riding hood
will waltz looney tunes
down a multicolored road
with dorothy and tin man

chanting prayers for every persuasion
children will be children again
as they must
and in time, through a lodestone
of behavioral differences
producing giant steps – footprints
footprints firmer than mine

RODLEY MONK

The Smile of My Friend's Mother

Roberto is drunk in the alley
crooning shouting crazed weeping
playing an imaginary guitar
to his lost loves.

He can no longer afford the bars
he cannot even afford a roof
except for the bushes
around the doctor's clinic
that accept him without question
as he plows the fallow fields
of his dreams
with a cheap green bottle
filled with bitter castoff fruit –
a bottle as green as the mountains
in the heart of Jalisco
where he was born into poverty
four decades and eight years ago
on the Cinquo de Mayo
the 9th of 9 children
the last of her eggs
she had breath to offer life.

They had to bury her
with her warm billowing breasts
with the milk he never tasted
and her broad smile that he never saw
he tries to imagine
because in the one photograph of her
that once existed
she looks solemn and a little afraid –
perhaps because the photographer
is an expense they can't afford
perhaps because the grinning husband beside her
would lose work lose heart get drunk
and beat her sometimes; but mostly because
she already has heaved seven children
into the world and secretly prays
her womb will dry up and god
will find someone else to bless
as she is already very tired at 37
and dreams of seeing her youngest
grow to manhood.

Roberto was named after a handsome star
she saw on the mayor's color television set
where she worked from time to time
as a kitchen maid, grateful
the mayor did not
rape her and paid her each day
spoke to her kindly,
at least this was the story told by his eldest sister
who became the mayor's mistress
to help support the family.

All this happened a long time ago
before he left the photograph of his mother
in the village where he was born
to come here to el Norte with dreams
of working like a mule
(and he did, like a mule)
to save enough money
to build a tomb
worthy of the mother
whose smile he never saw
whose milk he never tasted.

DIONNE BLAHA

Rocks

I wonder when you'll want to hear
about yourself.
Lollipops will err on the side
of colorful
Clowns about your humor
Runners on your grace.
What if the plants have more to tell you.
The spider that lies in wait,
the beetle walks
into the web
to feed someone else's babies.
Just a few more rocks near the ledges
where the water falls
the prayer pool is almost full

GWYN HENRY

The girl from the red. . .

told me that when an Indian dies
the relatives cut and burn their hair,
it is their custom

& the girl said that's what she did
when her mother died
& the girl was just twenty then
& didn't want to
but did

cut her long beautiful hair
& burned what she'd separated from herself
in a rusty little smoky
at night
in her back yard
under the stars

& it stunk to high heaven
while the moon filled up
with water

ERIN RODONI

Pregnant Women

Over breakfast
when you ask me if I dreamed
I shake my head
and look down into my coffee cup,
hide a secret smile.

I am not yet ready to tell you
that when I sleep beside you
I dream of pregnant women.

They rest upon fields of rice and wheat,
their doughy flesh expands
under a throbbing sun.
They are molded from within,
shaped by unseen hands.

From their skin, the scent of warmth,
baking bread, scalded milk.

Sometimes they are crouched, fetal,
curled inward like seeds,
murmuring lullabies
through the sleeping months of winter.
Sometimes they rotate slowly,
round globes,
complete, holy.

In my dreams they dance around me.
Their long arms caress my belly,
coax my unstretched flesh to soften
and, like yeast,
to rise.

I wake beside you
with the memory of fullness
teasing the edges of my body,
an almost-word upon the tongue,
the absence of a curve
I have never had.

To want this and not want it,
to alter our intimate universe of two
where we can drive at dawn
down empty, coastal highways.
Where we are free to wander,
abandon London,
shed San Francisco
silently fold our tent
and beat a hasty retreat
into the night.

But when I lie beside you
I feel gravity roar between us
and I want something in this world
that is half you
and half me.

The pregnant women moan,
their swollen bodies fold
them to the earth- rice paddies,
mud floors, antiseptic sheets
in long, white halls.
And I know that one day
I will lay my body willingly
upon that altar,
an offering to a pagan god
demanding blood
in exchange
for a miracle.

KIRSTEN QUINN

When Bad Children Grow Up

A man with big hands caught a firefly.
Captain Bug Catcher sat cushioned
at the Sac-town office.
Hey lightning bug, he says.
If you give me ten bucks,
I'll let you live 13 minutes instead of 15.

Sure, says the electric baby.
I'm not worth much anyways.
Besides, I'm rechargeable
and my parents don't mind
if you kill my battery.
You charged them just to be put out.
They'll give you anything
to see my ass light up.

He couldn't hear me
over the generator,
labeled State Budget.
Sounds good, bug, he says.
Don't go anywhere.

I can't, says the starlight child.
I'm stuck inside your giant hands.

Oh, right, he says.
He looks at the lightning-bolt bug,
gets serious,
points his nose in its direction
and says,
I'll be back.

DYLAN BARMMER

Place Holder

Give me some place
to put my poetry.

I have been pouring it
out into cracked chalices.

I have been selling it
in dirty back alleys.

I have been writing it
with my eyes half open.

I have been diluting it
from its purest essence.

Give me some place
to put my poetry.

I promise not to force
it in if it won't fit.

PAUL A. SZYMANSKI

Socks

they lie there
the browns, navy, black, gray, tan
presumably a couple
on the feet

sometimes there are strays
mismatches
the improbable orange sock that could not have a mate
some companions found, most not,
why the partnered became partnerless
the socks do not know

we are designed as pairs
to be tied, stuffed inside each other,
lived in darkness,
in drawers and shoes
why no one knows

this is what soul is

BOBBE VAN HISE

Haiku

Life is waning now
Passions of our youth subside
Heavens dreams arise!

Q and A

Are you afraid of dying, she asks, you write
about it so often lately. How do I answer
a granddaughter just beginning to live. I reply
I'm interviewing Death, checking credentials,
looking into all possibilities, curious.

What does it have to offer that will lure me
from this world I love and loathe. I'm not anxious
to leave, but when Death asks – *who gives this woman*
I want a willing answer – her mother earth
and father sky, estranged as they may be.

Sitting in different pews, they try to look comfortable.
The river is mantled in fire, air tender. Trees scroll
a calligraphy of shadows on the grass and far off
the tolling of a bell. What was the question?

Gloria Hewitt

Grey Fox

Slinking shadow with flickering fire-eyes,
Brush-tailed and grey as the moon.
Pricked ears and pointed nose point now at me,
Flame showing wary, startled surprise.

White needles gleam as the smoky wraith grins.
A flash of fear, apprehension,
But I stay frozen, captured.
Then pale blackness slips away between the pines.

JODIE SHULL

Cottonwood in Carlsbad

At the corner of Jefferson and Marron,
Across from a sports bar
that keeps changing hands,
stands a cottonwood tree.

Its leaves, flat and heart-shaped,
catch the wind,
flutter and shimmer,
going yellow in autumn,
and blowing down the highway like dying birds.

Seeds come in spring
and float in airy tufts of cotton over my car.
They cling to the hood for a moment,
but I have no ground for them.

I watch them drift down to the asphalt
or fly on to the dark water of the salt lagoon.
Once beloved for its bountiful offspring
by pioneers who planted its tender shoots
on treeless plains,
the cottonwood stands alone now
on this city's edge.

PHLEGM

In seventh grade, *rancor* and *boycott*
were part of spelling and vocabulary
lessons, when we'd spell, recite
its definition and place the word
securely in a sentence of our own.

By 1961, *boycott*, like its cousin *embargo*,
seemed, to seventh-graders, something
hidden deep in the mists of history
while *rancor* remained an adult reaction,
where we'd just be pissed off.

Week after week, the chosen words
appeared like arrows coasting
over our thirteen-year-old selves,
aimed at the well-spoken adults
our teacher hoped we'd become –

until *phlegm* entered our lessons
next to *aplomb*. We learned to build
phlegm with its two letters sliding
down past the line, its two letters
running uphill and hooked *e* and *m*.

Here was a word whose definition
we could lob across the classroom
with self-confidence (or *aplomb*).
Use it three times and it was ours
like a hankie we kept in our pocket.

I carried my vocabulary words,
including *adroit* and *disconcerting,*
wadded and shoved up my sleeve
like a maiden aunt who fancies
she's ready to dab her eyes or nose

at any moment. But years went by
and without rancor, I left behind
those language drills that came after
diagramming sentences, when words
sat on balanced, syntactical contraptions.

Much later, at a boozy promotion party
in a basement rec room I sipped
wine and watched a wise-cracking
firefighter holding court, trying
to come off smarter than average.

All at once, he turned on me
and taunted, *Betcha can't spell phlegm.*
Like spontaneous vomit or unwanted
mucus, *P-H-L-E-G-M* rose up and out
of my mouth. At that moment, I knew

I displayed my very own adroitness
and undisguised aplomb, while he
perched, disconcerted and wordless.

MAGGI ROARK

Lost

I take your hand
which once enfolded mine with fingers
certain of their strength and power

I search your face
so familiar as you turn to me,
each line etched upon my heart
by our countless years as one

Your eyes seek mine
yet gone from them is the heat,
the blazing force of passion
cooled now by drifting clouds of fear

Your mind, once compelled to dwell
in fierce logic and complexity,
has lost its way in the fog of disease
leaving you forgetful of even simple tasks

I loved you then; I love you now
yet my heart aches
with the memory of the man I knew
as I live with the man who remains

ode to izzy

izzy klein was a poet as genuine
as a sun rise
and don't you tell me no
cause come every January one
he'd leave his rent controlled ratty rooms
in bensonhurst take the subway to
grand central station
board the 8:03 miami express
to his bungalow
on the wrong side of the intracoastal
with its green corrugated tin roof
and yellow tongue-in-groove pine siding
and you know inside
not a single picture by michelangelo
and before they put up all those
high-rise condos he had this post card
view of the gulf stream
explaining how in the early mornings
the cloud formation looks like banks of rock
and if that ain't poetry then the
other guy never had miles to go
before he slept anyhow
izzy insisted the place was
poifect cause it'd be maybe
12 minutes from all the kosher restaurants
along collins and he'd snuggle inside
his place all winter occasionally
finding a widow woman
whose husband left her comfortable
and later he'd check into the

hotel fontainebleau cause he said
it made him feel like a mensch
like a guy with bit of money
going to the pool and sitting by a cabana
and the girl with the big boobs
would ask softly you comfortable mr. klein?
bit more seltzer mr. klein
another piece of knish?
and smiling he told me it was the only time
people called him mister
and said what a couple of bucks would do
so I should go finish high school
which I was gonna do anyhow and how
I got to know all about mr. frost
and for what reason cause izzy
you damn fool why'd the hell you
go ahead and die on me you
unhandsome unrhymable poet

TERRY A. SEVERHILL

Mike

He dropped out of school
And he didn't know why.
And then he joined the Marines
And they trained him
And they sent him off to war
And he didn't know why.
And he did his job
And he came home
And they praised him.
And then he shot himself
And they don't know why.

LINDA ENGEL AMUNDSON

The Fish On The Page

A fish swam through rocky words
to the edge of the page
cast its gaze
upon fruit flies dancing
above over-ripe plums.
The ink blue fish spat out a question mark as
bait.

The flies hovered nearer,
drunk on plummy wine.
With a leap off the page
mouth agape, the fish
fell into my teacup.
I carried the blue ink fish
in my cup of lukewarm
green tea to the
porcelain creek
to be swept out
to the ink black sea.

Federico Moramarco

The City of Eden

You mean Garden, don't you?

No, city, although there are apple trees there,
and snakes, lots of them, those you can see

and those you can't. Adam names streets
as well as animals, and bridges that surge over rivers.

Eve is there as well, sitting on a restaurant stool,
eating ribs. And somewhere there's a scowling Satan,

angry as Ahab shaking his fist at God,
watching Adam and Eve making innocent love

before the fall, hissing and moaning
because he can't stand seeing two people so happy,

here miles from their forest glen,
in the city of Eden, the city of now, and then.

JON WESICK

Seagulls in Their Sailors' Jackets

Dress shirts unfolded
underwear and worn socks
on the carpet by the suitcase.
No enthusiasm for packing
or tomorrow's flight –
crowded seats, lack of sleep,
that dreary striptease at airport security.

I leave it; go to the old theater instead
where gold fixtures adorn the screen,
earrings on a silent-movie actress,
and Oscar, the duckbilled terrier,
loiters by the concession stand
bumming spare change
and scratches behind the ear.

Later unable to face the tedium
of toiletries, I choose winding stairs
and concrete sea wall. On the sand
gulls in gray pea coats huddle against
the wind. Air bladders
from shipwrecked kelp crunch
underfoot. The surf plays tag
with dry shoes. In the distance
the Encina Power Plant stands guard.
Its smokestack with flashing red light
warns airplanes away
 for now

Ken Schedler

My Cat Unlocks The Universe

My cat cares naught for lofty thought
Though she listens to me daily
Only when I obey her prompts
Do her feet and tail move gaily

My poems behave in much the same way
There cleverness lies dead on the page
But if what I sense is what I relay
My muse comes forth from her cage

Then the meter reflects the meaning
The rhymes become apropos
And the reader's mind awakens
To what the universe wants us to know

DHR Fishman

on the one about plums,
or Mrs. B. reads a poem to the class

– for PB

in the oppressive heat of an Indian summer classroom
(105º in the shade)
too still air

along with your old school English
of etymologies and
diagramming sentences
you schooled true passion
for poetry into us.

how did you slip the radical words of your youth
– that true religion –
past
our overboiling chemical soups
sudden shifts of hormonal tides
dazed brains
the unlistening ears of
bored unbelievers

the certain power
of your pronouncing pleasure
vs.
middle school classroom audience:

unwashed boys
farting, guffawing
cheating at spelling
listening only to boy-told
untrue tales of groping glory

Clearasiled girls with blow-dried hair
strawberry glossed lips whispering about each other "slut"″
peddling dope from lockers

clutching close
anxious secrets:
threads of hair pushing through skin
sudden swells and smells of flesh
inner and outer eruptions

us as awkward
know-it-all know-nothings,
tweenagers – how seduce that
most jaded of palates?

your recipe:

unfridging fruit
in sensuous syllables

into the fevered bodies
in that sweaty-hot room

instilling
the chillest sweet cool
cool river of sound
sweet-sluicing down spines
purpling our green,
ripening the juicy flesh

how could I forget to remember
to thank you for the cool syllables,
the open door,
the vision of who I knew I'd never be but
you still knew I would.

<div align="right">KATE HARDING</div>

Apartment Hunting

Only minutes ago, the landlady
with tight curls and a gold cross
told my stepmother, Anita,
this apartment was taken.
Now, she's handing me the key.
I'm eighteen.

Baskin Robbins fired me
for serving too much ice cream
per cone.

I step to the bay window.
Palm trees wave below me.
Half a block away, Anita,
in a new suit, sits in the passenger
side of my mother's old car.
Her black hair shines. I'm wearing
torn jeans. My straw colored hair
needs brushing. All I had to do
to rent this apartment
was show up in my white skin.

Anita was seeing my dad before
my mother died. Her salsa burns
my throat. She loves large, lime-
colored paper roses. She's beautiful,
with long brown legs. *All her sins.*
She's worked as a hairdresser
at the same shop for twenty years.
She doesn't drop socks on the rug
or burn stews to lava crusts.
Until this moment I was sure
I was the one to feel sorry for.

I smile at our new landlady.
Already I can see lime roses
in a bottle by the window.

Agoraphobia, Tuesday

I want to be one of those women
who think they will buy the flowers themselves,
and then do it. Who walk out the door
as if there is an opening,
who walk out onto the steps
as if it is solid ground?
My therapist tells me to make tally marks
for every day I leave the house
and to reward myself for leaving.
In thick tights,
flat shoes,
I feel smaller and smaller
with each step.
Buildings,
cars rushing past,
an overhang I imagine
jumping off of, cracking,
people in a cafe laugh –
I tell myself it isn't at me.
I repeat my mantras like a nun with a rosary,
like a holy man,
I practice.
I walk by a row of men pulling up weeds,
inmates in their orange vests,
and I do not imagine
the way they stop,
one by one,
earth in their hands,

watching me walk down the street
as I repeat to myself,
"No one wants to harm you,
no one is thinking of harming you."

Corporate Poet

IBM, Halliburton, Ford –
even Hershey's Chocolates and e-Bay
all said no.

Actually, they didn't say anything.

In the old days
– six seconds ago –
a resumé would have come back
in a self-addressed, stamped envelope
and a note might have explained
the rejection:
> *Royal Dutch Petroleum regrets*
> *it has no such employment opportunity available.*

or
> *At the present time,*
> *Johnson & Johnson has no opening*
> *matching the position for which you have applied.*

Today, nothing comes back.
The resumé wings into the ether and,
like a poem
or hope or fear,
just lingers there.
Even companies that pioneer
information technology – Intel, Google –
don't respond.

My dream job
 Senior Vice President, Poetry
can't be found
in the annual report
or on the swollen list
of corporate executives.

So who mines the company soul?
Who sings its song?
Who creates its lore, its legend, its legacy?

Can't the big wigs see
there is poetry in their designs,
in the toil of their workers,
the use their products get,
the satisfaction, even the joy
they bring?

Isn't all that worth
a corner office?
 Please, come in, have a seat.
 Here at Acme Bolts,
 we consider our products works of art,
 our workers artists
 in zinc, galvanized steel, copper.
 In fact, I've written this poem about
 our revolutionary new #302 Lag Screw series.

Wouldn't a meeting like this
help sales and contribute
to the bottom line?

No word yesterday
from Alpo or Goodyear Tire & Rubber.
Nothing from CitiBank today.
Tomorrow,
I expect not to hear back
from Caterpillar.
The clerk down at the Unemployment Insurance office
is going to be annoyed with me
again.
I'll resist retraining.
She'll insist on it.

Hmm.
There may be a poem in that.

MALIA HAINES-STEWART

In Another

When I think of you,

I see a little girl trying
to keep her house of sticks
from falling
into a heap on the ground.

and I remember that time
when I put my lips to a pillow
and cried
while his breath made rhymes
on the flesh above my spine—

I think you felt that too.

We don't need to talk about it.

It's a part of you
and you hear it in other people's

inhales and
exhales

so you try to change your own
exhales and inhales

but the clock stopped on that moment
and though you try,

it won't start up again.

JILL MOSES

Tree giving instructions

I have rooted myself here for many years–
my bark is tough and knobs grow on my skin like breasts.
I reach my arms up to the blue to seek answers,
but they don't always arrive.

I am not sure if the earth holds me
or if I hold the sky but I can tell you this –
I hold particles of light in my green palms
and move to the rhythms of the breeze.

I have toughened up from years of corrosion,
from rain beating down on me.
I gather birds in my arms.
They twitter around me as if I were a coat rack
holding the weight of every day.

I wrinkle like the skin of a rhinoceros, my fingers are gnarled
but I stand tall. I do not waver
no matter how strong the winds push.
Occasionally, a branch breaks from the heaviness of snow
or a leaf falls from an overzealous wind.

I am not afraid of the dark or the howl of the coyote.
You too will survive the ways of the wind,
 the sound of the moon.
Just listen.

Bingo and Freddie

It was long after cyber-culture had imperiled
the economy, humans had failed, animals
were in charge; a new environment

Where Freddie watched Bingo, his benefactor,
from the San Diego Zoo, in his torn copra T-shirt
STEALTH IS THE WEALTH OF THE JUNGLE.

Bingo's big eloquent eyes a-goggle, twirling his
signing stick in the sand, Nothing must be wasted!
Our bodies store glycogen, an animal starch

Imploding upon command!. Bingo pops a yellow
mound of citrus in his mouth, spits seeds
resonating hope into an old canteen marked LIFE!

We are not mere one-cell amoeba, Freddie,
salute our astute gatekeepers, the giraffes
who peer down on the tragedies of man.

We admire your leadership, signs Freddie, whose
ancestors suffered his shameful nickname,
Freddie Mac. You deserve the Aqua Android Trophy

For discovering over a dozen freshets that filled
cisterns for our thirsty, you have attended
our English classes as we have learned

From you what we should have known, to respect
the animal spirit that lives in a Mongolian lamb,
give up salad bars and still be insectivorus,

Wipe our tasty leaf-cups clean; and way before the age
of Pleistocene you animals have been our friends,
fear, the only obstacle, but now the Black Mamba

Is wearing a radio wedding ring. You leave no woos
in the woods, send your super Jaguar Junta
to track down our maverick civvies

Who steal food, hide in the vast suborial erosion.
You, my good friend Bingo, know why we
cling to our precious canines and felines.

For their ineluctable love, endearing and enduring,
pure animus, breath, air, soul, who share
their lives with us, as we with yours,

For who knows more about the economy than
you animals? That is true, mused Bingo,
we are fully and finally empowered, not to eat you,

But to love you, of this be well assured.

CARRIE MONIZ

Desert Night, Ocotillo

(year four of your seven-year sentence)

I erect my tent, avoiding hostile silhouettes of jumping cholla.
Still, one buries its barb in my thick sole, pins it to the soft foam
of my sandal. I carve it out with an old knife, calloused flesh curls
like shaved soap. I put boots on, build a fire, fry leftover spaghetti
in a pan, watch as a kangaroo rat runs for the wood pile and is
crushed by a toppling log. I bury it in the white sand, scour the
pan, light a joint in the embers, wonder if you stomached any
small deaths today.

spiritual moaning

I'm getting ready to write a poem
by writing this poem about getting ready
it will have to include my pacing
up and down the long hallway
where that Klimpt print of a woman hangs
she's dressed in a floor-length golden gown
seemingly tacked together from a poet's post-it notes
and various kinds of fish dredged from the Danube

the long hallway is itself a story I like to tell
to all the dreaming rooms of my house
it carries the history of getting ready
a history that leads down the hill
past the pregnant child waiting at the stoplight
lethal traffic slicing by just an arm's length away

she drums her fleshy fist
against the crossing signal button
as if the crosswalk were a door
and not the path from the golden gown
to the homeless man half a mile south
taking his only chair of the day in the public library

the man rocks back and forth at a long reading table
runs his fingers across the initials carved into it
as though plumbing a secret Braille text
mutters to himself in fluent pig Latin
his own poem about what it's like to be god
to fear the ferocious silence of the Trappists
to hear the incessant flow of prayers

rush past his ears every waking hour
as if he were a stone in the rapids
while he looks forward all week
to his day off on Sunday

DEBORAH ALLBRITAIN

Rhiannon

Rhiannon is taking fish oil supplements,
the latest autism fad for improving language and cognition.
Inside my office the rotted fumes of guttered fish
release their thick scent from the pores
of this three year old girl, feisty little imp
with heavy bangs and a moon-shaped face
who at once switches off the light, pulls me
down on the carpet signing "horse" and
nuzzles against me on all fours, my head spinning
with that foul smell which is suddenly
the stench of old hay matted down
from sweat and a night's rain; righting the brains
of new foals with its wild perfume.
Under the table steam rises from our flanks
giggles erupt like flowers as Rhiannon tells
me to sleep and smoothes my mane of blonde hair
down my bony shoulder, admiring me in the shadows,
her black eyes rippling my heart.

RYAN FORSYTHE

Orange

stepping off the train in Agra
 I am surrounded by outstretched hands
not so much begging as waiting
 for that which will come sooner or later
 food, money, anything
only in India for 24 hours
 and I'm already hardened to the pleas,
but nothing has prepared me for one sight in particular
 a boy

for a moment, it seems he is sporting a pair of slippers
but no, it is his feet that are three times normal size
 is this the look of elephantiasis?
toes like empty bags
just dangling
 no longer connected to bone or muscle

it's as if comedian Howie Mandel
instead of blowing those rubber medical gloves over his head
 blew them over his foot
despite his condition the boy owns a contagious smile
he knows someone will give him a piece of fruit
 or a bit of their bread
 then maybe he won't be hungry for another hour

before arriving, most of what I knew
 about the country was limited
gleaned from random magazine articles
 and the occasional TV show

sacred cows and Bollywood musicals –
that sort of thing
and now here is the boy
I look down at the orange in my hand
then back to the boy

SHARON LAABS

Grasshopper Girl

Just another day on Interstate Five
headed south toward the city,
when a dignified hopper
skids onto my window,
one bug eye on me,
the other on the road.

Zoom, zoom, vahroom
the blur of a jacket—
"Harley" across the back,
boots to the knees, pants so tight
her tiny bent legs—look almost—insect-like.

As hopper and I gaze
on this amazing scene
we're left to wonder—
what does it mean?

Is she his kind of creature—or mine?

The Diner

As usual we gathered, the two of us
for black coffee and lengthy conversation
at our local diner,
the ol' Flamingo Cafe

Same old customers gather,
the old loners in their 60's
a haggard cook,
the fat waitress who'll love you
to death,
and the two of us bums
with nothing but time on our hands

We can go hours on end
yapping about nothing at all
drinking that black water
'till were fried at the nerve ends
as the clock starts spinning. . .

I look up from time to time
as that old woman waddles by us
with those classic hot plates of
steak an' eggs,
biscuits under that gray blanket of gravy –
diner's delight!

There's nothing like it
hanging out with those midnight souls
at that All-American hide out,
hospitable and humble.

BARBARA DEMING

Ghosts

On a hill at midnight high above
the Little Big Horn,
wait for history to fill
the air, remembered spirits everywhere.

Sabers rattling, guns belching.
horses & men cry out
in fear, in death;
you hear history fill
the air, battle spirits everywhere.

Chants of Sioux medicine men,
elders' wise words cast aside;
laughter as women scalp fair heads,
remove the penetrating parts.
You see history in
the air, singing spirits everywhere.

Winds still dance through
greasy grass
on hills above the Big Horn.
But brave voices are stilled;

whiskey, drugs & welfare
crush a proud people.
You feel silence in
the air, forgotten spirits everywhere.

The Tea Party

He loved his tea at three or so.
I'd heat the dented kettle, pour
a stream of steaming water on
a tea bag in his Spode cup,
but that day I poured
steaming water on loose tea
in a new teapot and let it steep
while my old man put down
his rake and cleaned up,
smiled and winked at me.
I'd spotted the white china teapot
in a thrift shop of St. Barnabas,
a church on Oxford Street.
Rich parishioners' castoffs put
my prized chipped Spode
to shame. The teapot without
a defect for two bucks gleamed
like an icicle in moonlight.
I stopped at an A & P
on my way home, picked up
a package of Fig Newtons,
and I had the makings of
a tea party for my old man and me
I still have the white china teapot
high on a shelf I can hardly reach.

MELINDA PALACIO

Outlaw Zone

Arizona,
lull me back
to sun rays on mountains,
full moon hikes and coyote cries,
heat from windless days, where
people dared build
cities in a desert.

Don't piss me off, Arizona,
don't go back to those ugly years
of no Dr. King days with your
sweeps and roundups,
sounds like a rodeo, *¿que no?*
Don't prey on your people, *gente*
browner than an Arizona sunset.

Shoes, you say.
You can tell by their shoes.
Shoes say it all:
immigrante, illegal.

Don't tell me where you came from
or how the West was won
or why you think Arizona,
land of little water, chollas,
bottlebrush sage, ocotillos, saguaros
is only for those whose skin burns pink.
Arizona,
add air to your name,
Air-uh-zone-uh. Air-a-
zone for legals,
ahh-ry-zo-naaa.

Arizona,
don't forget which country you come from.

CAROL ST. JOHN

Capricorn and Pisces

Sea-goat is my brother,
Roams deep and far and wide.
Little fishes splash and sparkle sunshine at the river's mouth,
Listening to his tales of pearls reflecting moonlight
 from the ocean floor.
Riverbed's too narrow, he won't stay for long.
Sea-goat swims the silent sea alone.

Man-goat is my lover.
Comes to the moss rocks by the stream, eyes flashing sunlight
Piping a soft, slow song to my undine heart
Caresses like the smooth, cool water.
River song in the forest.

Unicorn is my dream.
Floating breeze and warming sun,
Singing river, living earth.
Joy in heart love, light and still and strong.

BRAD MCMURREY

Words

Sunday morning, sitting on the sofa,
the man reads Jack Gilbert's admonition to
". . .enjoy our lives because that's what God wants."

The man remembers that old song,
so simple and cheerful,
parakeets around the world sang it for years:
"Don't worry, be happy."

The man puts down Jack Gilbert,
and raises the Sunday newspaper,
where he sees permanent sorrow
in the face of the mother with a murdered child.

Now the man remembers Teddy Roosevelt, who,
as he lowered his wife in a pine tree box, felt,
". . .the light went from my life forever."

Words can flow easily like liquid lava
down a now lifeless slope.

But when lava is exposed to earth and air,
and feels the coldness of the world's breath,
it can be forced to stop, sit down,
and crack under the weight of reality.

Sometimes words are proven false,
and neither God nor parakeets
can tell us what to feel.

JENNY MINNITI-SHIPPLEY

Mountain Climbing Blues

Linnea, October's marching
towards me with his heavy boots on.
Old friend, here comes October,
and he's got those heavy boots on.
I hike through Yosemite, and still
can't believe you're gone.

I watch these red mountains
rising high above me.
I stare at that red mountain,
how it rises high above me.
I squint into the copper sun,
see places you should be.

We'd be in Carolina, Linnea,
dancing barefoot on the grass.
We should've stayed in Carolina,
dancing barefoot in the grass.
You came to California
two years ago – and passed

from this lonely desert
in a tumble of rocks and air.
Linnea, you left your last desert
in a tumble of rocks and air.
The climbing rope gave way,
and now, how I miss your yellow hair.

Barefoot in the stream, I watch
the shadows cross the water.
I stand barefoot in this stream
and watch shadows cross the water.
I come here with October, lower
my head for grief's worn halter.

CURRAN JEFFERY

Let Us Walk Quietly

Let us walk quietly
With those who have gone before
Let us talk silently
With those who breathe no more

Let us touch with memory
Faded days of years now past
Spring river swelled with forest rain
Fed us well and made us laugh

Tender trout – that morning's catch
Roasted on the river bank
That spring, those trout,
My youth are gone

But that river flows each spring
And I hear my father laugh

Sacred Hands

– a poem for YONA WELCH

The soft yellow ribboned shirt
contrasts dark earthen hands
to reveal a snapshot of grace.
Weathered fingers cradle
a carved stone pipe.
It's like you are holding the stories
in the bowl when the wind
picks up and moves your ribbons
in a kinetic bloom of explanation.
You are pipe and wind and ribbon
soaring atop the red rock of the Kumeyaay.
Smokey Mountain pine needles wound round
stitched over and under
sewing a sturdy union of truth
capable of holding the offering
of the cloud people and nourishing
the parched mouths of those who sing out.
Ancient Torrey Pine stands as witness,
a five needled native rooted
on this soil of the middle Eocene.
Forty eight million years of waiting
for this cup to hold this space.
And like the gourd rattle
containing seed sounds,
I know all this wisdom
is contained in me
waiting to be played.

CHRIS VANNOY

Coyote Will Lead Them

On the border they wait like crows
dance from foot to foot
naked on a hill of clay
rock hard
like the journey that led them to this hopeful perch
their thin plaid shirts flap in anticipation
they wait for a good wind
a moonless night
to carry them north

Coyote will lead them
down
over rivers
up
through arroyo's twisted as snakes
along rabbit paths of mud and sage brush
his nose to the ground
Coyote barks RUN
now STOP
BE QUIET
RUN
WAIT HERE

ears twitch from side to side
taste the air for movement
strain to hear *La Migre,* the hawk armed with
infra-red eyes
Coyote barks RUN FAST
they scramble through holes
lights and voices catch some

(rabbits in the snare of politics)
others disappear
fly to find passage to promised land
through radial arms of spiders web

on the border they wait
like crows
Coyote will lead them
NORTH

LUCIO COOPER

Trees in a tunnel

 A distant figure
black
in the jealous pale night-
distant trees
tortured green
 cold as the night
 with powder blue lungs
and white halos,
where angels scavenge
 tree tops,
with razors in their backs
 and only the moon shelters the stars,

 as the city awakens in the night.

Origins

I'm from the squat, brown house
on Claydelle where two stucco
and stone pillars have sat,
being perched upon by many
generations of my family, we
have looked down dirt roads
that are now paved over.

I'm from Tres Piños apartments
on Mollison where the stairs
shook when my neighbor's dad
descended them until he was
the first dad I knew that died.

I'm from year around school
on track C and we were better
than you at four square
and tetherball and wall ball.

I'm from scrunchies and layered
slouchy socks like we were
in The Babysitter's Club and I
was always the president, Kristy.

I'm from threaded friendship
bracelets that fray and never break.

I'm from lawn lunch at John
Ballantyne Elementary and you
could huddle up on my mom's blanket
if your parents couldn't make it.

I'm from a family of females
and the only men that stick around
are the ones born into it.

I'm from tortillas that are buttered
and salted and rolled into golden
scrolls dripping stories
of la llorona and el cucuy.

I'm from my great grandmother's
double handed wave goodbye
from her porch on Claydelle, now
blue and fenced in, and
no longer mine.

BILLIE DEE

Grass Valley

My old blind setter is frozen
on point, ears cocked,
nose twitching with reverie
of bird scent, fallow field sun bleached

in October, blond grasses nodding
yes, yes and bless you
one more season friend,
hidden bevy, amber light.

Noble Savage

It's in the way my headlights
raise upon the inland brush
like a wolf at prowl.

It's in the mist that rises
from my glass as I breathe
over the ice.

It's the hands of the man a few booths over
as he cups his phone in
to hide its face from the waitress –

she wraps her arm around another girl,
and introduces her as her
cousin.

The man nods and orders a drink – "My wife
will be joining me shortly,"
he says.

And it's in there too, like bad sex
in a steel apartment or
the eventual balance of one foot
over the eventual fall
of two –

madness comes in on toe tips,
and leaves his tracks like
fossils in holy tar.

the cage

the nest was lined
with measured twigs
and manicured lies,
she built a symmetry of gaps
to stave young trust

we plucked our down
to rush the growth of flight

even in the later years
when she tried
to mend the broken things
we would not open the windows
would not let her in
she gestured with bewildered wings
uttering unformable words
of loss and forgiveness
and all we saw
were the sharp edges
of a beautiful world,
without a single breeze.

TERRY VENTURA

My Mother's Pearls

One by one
White drops
They fall to the floor
Hong Kong images
Junks
Hilltop vista
Cigarette tower
I purchase the string on a trip
Gave them to her and years later
she gave them to me as a gift
Said she would never wear them again
And then one day. . .

My mother's pearls
Drop in slow motion
One by one
Plaques and tangles
Obscure her mind

Where do you go mother
Do you dream of your youth
Your eyes are blank
Absorbed
A shell

You'll be gone someday
The other side
And I'll see you again
young and full of life.

In dreams
together

DIANTHA L. ZSCHOCHE

You Teach Me:

Reflections after 10 Weeks as a Hospice Chaplain Intern

You come to me in many guises
Knarled or lithe
Mute or verbose
In the here and now
Or the there and then
You cause my nose to wrinkle
My heart to catch
My eyes to water
My lips to turn up
But always you teach me respect
You teach me courage
Your teach me faithfulness
You teach me humility
And if I am faithful to just be present with you
Then perhaps we can sit together in his presence
And I can remind you that God loves you
Enough to send fallible me
So you can see the extent of God's grace towards us.

CLIFTON KING

Mount St. Helens

– May 18, 1980

Today the sea whispers her secrets
to me, though she has not always
been my neighbor. In those years
that survived our youth, we roamed
the conifered coast of Oregon;
climbed mountains that bled rivers
into the Pacific; stalked salmon
and steelhead; watched a generation
of alder and Douglas fir fall amidst
a cacophony of chain saws; waited
hours for a shot at elk that foraged
in coastal scrub dense as
 a Robert Lowell poem.
And always the cloud-cluttered sky,
formations that looked like banks
of rock, watched over us.
Then, that day in May stone
and sky were one when a torrent
of molten rock, mud and uprooted
forest flowed down cindered slopes.
And ash rose into the stratosphere,
an impersonal gray coat draped
across the shoulders of the earth.
All we could do was watch
from that small meadow where
we stopped to pick huckleberries.
I can still recall the way trees quivered,
jays fell silent –
 how tightly you held my hand.

DIANE FUNSTON

Miracles

There are no miracles in stillness.
All wonder comes through movement,
whether waves in water
or the seriousness of stone.

There is wisdom in the layers of mountains.
Spirituality filters through treetops,
changing seasonal wardrobes,
listening to the sermons of ravens.

There is no love within fear.
No story without preface,
no touch without risk,
and no remembered dream
without first awakening.

ROGER FUNSTON

Finally Home

I went to visit friends after years of invitations
To see their twenty acres of paradise on the Columbia River
Gorge
The hard dirt road heads down the hill
A bridge crossing a dry creek roars in the winter
The smell of pine trees
The log cabin they built, filled with love

I always envied their connection to the land
Changing jobs, changing lives
Leaving not negotiable
While I kept moving, to greener pastures. . .so I thought
Each place okay, but never feeling at home
Restless, always restless

But one day I walked away
From my suffocating white-wall existence
And found love
And found my place
Room to spread out and breathe again
Decorated Victorian style
Filled with bright colors, antiques, Paris posters

A dry creek runs behind the house
Woodpeckers fly between pine and oak trees
A deer bounds over the fence
Wood is stacked on the deck, ready for winter
An unobstructed view of Tehachapi hills
Coyotes howl, bobcats prowl

Escaping the urban world, business meeting
Driving though the desert past saltbush and creosote
The setting sun spilling waves of orange light
 over cumulus clouds
The exhilaration of speeding down the open road
Up and over dips, around curves, past wind turbines
The breeze blowing across my face through the open window

The air cools with rising elevation and the coming of nightfall
Ten thousand stars, reclining quarter moon
Hills dotted with house lights

Bats and owls overhead
Watch out! Deer crossing the road
Getting close to my one and a half acres of Eden

Past the tree in the middle of the road
Up the hard dirt driveway
Up the stairs
Dogs barking
Reunited with my lover
Finally home

JOAN GERSTEIN

Sun Sleeps In

Not one to lie on my back during the day
gazing at cloud formations in the sky,
I look up to see where the sun sits.
Behind the gray granite haze, she
is reluctant to rise, peek through
white edges that open for her presence.
The sun is languorous, sleeping in.
I understand that feeling.
Working all your life and discovering
the luxury of taking the day off.
This summer the sun is resting,
Let the clouds do all the work.
She finds that the world,
always on her shoulders,
gets by just fine.

KRISTEN SCOTT

Joan Didion on Haight and Ashbury

Midwestern face
recognized in thick black
sunglasses – your camera's
eye your undamaged lens,
Slouching Towards Bethlehem
between Haight and Ashbury
sipping gin-and-hot-water "to blunt the
pain," the *Posts* deadlines as your trip –

on San Francisco's Haight, Deadeye's
preaching opiates to Comrade Laski's
red book, and you are caught –
a caged bird, a beautiful poem,
a central valley, a chipped pastel building
on *7000 Romaine, Los Angeles 38*
paralyzed symbol between the pages.
did you find your bend in the river
Joan Didion? your cottonwoods in
that dusty Colorado theater, where
you watched John Wayne stroll
off the screen into Carmel valley
Where the Kissing Never Stops –

"The Duke will have Bordeaux"
you and Pilar drink Pouilly-
Fuissè in Chapultepec Park.
your mind with Joan Baez
in Newport your thick black
sunglasses floating somewhere
on the pacific horizon.

GARY WINTERS

unknown woman

gaze on her face and never be the same
catch a quick smile and have no doubts at all
watch her walk and be in awe forever
knowing perfection is in every move
feel your body vibrate each time she speaks
listen to her voice and hear mystery
gather her thoughts and keep them together
preferably in an inside pocket
treasure every crystal second with her
even though time stands still in her presence
if she can't stay near you and has to go
wish her courage and strength to carry on
let her know you have eyes to see her glint
your entire being says thanks for the dance

JAN GALLAGHER

Reflection in a Mirror

Pale lamp light, a bed
A woman sits on the edge
Tousled gray hair
Frames her face with curls
Her back is straight.
Perhaps it is a trick of the mirror
Or perhaps shadows create
The illusion of smoldering embers

SANDY CARPENTER

As For Walls

– I'm not 68, I'm 18 with a half century of experience.
<div align="right">

– Anonymous
</div>

Narrow world to a stranger's eye, and mine:
Expanse of wrinkled sheets, impassioned breath;
we ignored ivy drapes, shag carrot carpet.
Enough, the five-buck motel's fittings are old.
The weary desk clerk is quiet as a grave
when that key's handed on without a glance.
Add bathroom's grout, black like the sin we're in.

Narrow, sure. Yet wide as needed and full
of tilted lamp shades, wild wallpaper pressed
against that maple headboard, the door twice locked.
And we are what we are and where we shouldn't be.
Aims are alien; not yet woman or man
but girl and boy, someone we'd not forget.
Amoral as two puppies with shut eyes,
we swallow sunflower seeds to sow our lies.

No queen am I, no real king are you
yet royalty has nothing more than we.
A quiet radio that plays like hands
over a boy's bare chest, a voice smoothes
some scared skin, even more than had it not
sparked love in the dark. Our world
goes gray as the bayed window – just as bleak.
We begin to dress, stand in our underwear,
ask, *Saturday?* struggling not to stare.

MICHAEL LEE TREADWAY

Mission/78

I fell in love with the girl in the rear view mirror
 as I drove home from school today.
She wore unassuming white sunglasses
 and followed behind me most of the way.
I glanced back again and again
 her brown hair crinkled about her head.
She could have sped and passed around me
 but remained behind me instead.
Eventually we parted ways
 I went east and she went south.
As she passed she turned and gazed
 with an upturned nose and smirking mouth.

SARAH B. MARSH-REBELO

Persistence

What is that tap tap tap
that elegant shift
when the mind stirs
like the dormouse
exquisite in a velvet coat
patiently kneading her nest to perfection.

Blot

A shaver in short pants, I had yet to embrace seven
 – age of reason
for some – when it all started. The month May, the day Mom's
birthday. How I'd pay for her present never crossed my mind as

I strayed the seven crooked blocks downtown to Woolworth's.
A necklace or scarf, I thought, skimming Accessories,
 then recalled
how she abhorred constriction around her swan-lithe neck.

A brooch? She already had one – a wreath of wild lilac she wore
at weddings. I hopped to Stationery. Writing paper?
 No, she still had
a thick tablet. Ink, Ah! I'd noticed her ink line sinking. Black,

blue or red? Tipping my booted feet, I stretched my reach,
pinched my fingers around a bottle of Royal Red & skipped out the
store, up Jail Street, past the fancy shops on Main & the fresh

whiff of cake & pumpernickel from Fay's Bakery, onto the short
cut through St. Jude's Church graveyard – where ghosts creaked
in blackened tombs – past Mooney's Tavern on High Road,

the eerie gate of Jacobs Undertakers, & down the avenue of shingle,
bay-window houses to number 47,
 where the blue door stood forever
askance, & along the tiled hallway to the kitchen, where Mom was

cooking lamb dinner in a fragrant mist of freshly chopped mint,
& handed her the naked bottle of Royal Red ink.
 "For your birthday,"
I panted. After a brief pause & feather flick of eye lash,
 her brown

eyes ignited. "Ooh, thank you, dear boy" she smiled,
"I'm almost
out of ink," & plunking the fat-bellied bottle on the counter,
she went
on basting the lamb. Peering back over dimmed decades, I can't

help but wonder if she knew the gift was lifted.
Or did she assume
my stepdad had spared me a few pennies of his beer money?
I also wonder,
if she had dropped the lamb,
clobbered me across the ear & marched

me down to Woolworth's to return the precious lode,
would my long,
illustrious career in the financial underworld have ever
taken off, & how else
would my star-smitten eyes have missed
the emblazoned arrow to logic?

How else would I have gained maximum security
for the rest of my life?

PAUL COLALUCA

Conversation With Quotes

Richard Bach. . .is it really you!
On this plane, most of the time.
I've read all your books.
We read what we need to learn.

All your experiences,
Wishes are powerful tools.
did they really happen?
True for me is what matters.

In *Illusions,* Shimoda
We choose our own Messiahs.
when he walked through the wall,
Just molecules passing by.

I wanted to go with him.
Choose that belief and it's yours.
I know it's possible, but,
You learn to find out the known.

I know, I mean yes, I know.
Whatever we hold in thought,
There's a part of me,
comes true in experience.

that understands exactly,
Friends will know you better,
the things you've written about
in the first minute of meeting,

Sometimes my friends just smile at me.
than others in a thousand years.
I don't know if I'll get there.
Risk the life you would have had.

JOANNE D'AMATO

The Scent of Citrus Tea

While others in the house sleep
I sit with Grandma on the patio.
Its slate still cool with the dew of
an early summer morning, the spice
of honeysuckle seasons the air,
as we sip tea. Hot lemon water,
fresh spearmint leaves and fennel seeds.
She holds the cup to her lips
and breathes in the scent of fresh citrus,
content in thoughts near to her heart.

Young and enchanted with the freshness
of our quiet time together, I wait,
eager for the moment she will gently
rest the thin china cup upon its mate.
A faint chime echoes from the saucer's rim,
breaks the hush of silence. She starts.

And as she speaks she takes me back
to a time when she was a young girl,
growing up in Sicily, the joy she felt
at sixteen, seeing America for the first
time. My Grandfather and their love
for one another.

The meaning is lost in the translation
she would say as she interweaves Italian
to enrich her stories. Though some things
slip away, the warmth of her words
create poetic images that allow me
to live Grandma's life.

KATHLEEN PECKHAM

Idyllwild Midsummer Moon

We've gathered in this amphitheater
to see and hear great poets.

So I won't have to climb to the benches
or struggle down on
or up from a blanket
a friend brought a chair.

Warm night air
vanilla-scented from the old trees
fingers my skin.
From behind the eastern mountains

a full moon edges up.
Parachutes hung
for afternoon shade
billow like giant jellies
in a dry sea.

On a lower terrace
a minor riot erupts.
Seems the holes we thought
housed gophers
are homes for rattlers
who've turned out to party.
I tell my neighbor

I'm glad we're up here.
"Well," he drawls
"I've seen three already
slithering to rendezvous."

Awkwardly
I pull both feet up
to the folding chair
squiggle into a comfy balance.
I'll remember this night
in a paradise with serpents
till I no longer remember things.

CLAUDIA POQUOC

Never Let the Desert Get You Down

Have you ever run into with those desert thugs
while on a windy twilight trek?
Like when Saguaro shadows after you
scaring you half to death.
If you make the mistake – try to run away,
ocotillo boys stab you in the back.
Then when you least expect it,
a cholla gang jumps you and pins you down.
Once down, the fire ants or Solenopsis
(a name for a miniature dinosaur)
gnaw a path up your pant leg or down your sleeve,
then tunnel into your nose or ear;
and scorpion side-steps in with his version of
"a shot in the dark."
All this time, rattlesnake encircles you for
the last act with no curtain call.
Next morning,
buzzard picks his teeth with a metatarsal and says,
"Ya' know, everything's beautiful in its own way."
While raven cackling high above sings,
"Oh, what a night!"

CARMELA ZERMENO

Train Track Walking

My aunt led us like ducks, single file,
the back way, through the railroad tracks.
My mom and my cousin's mom were sisters
and my dad and their dad were brothers.
We were closer than close.
The Friday morning walk to Doheny Beach
took thirty minutes. We kids walked on
the railroad ties. We imagined tight rope
feats of balance. At other times we crunched
gravel under our flip-flops. It hurt.
Cheap sandals don't work for gravel.
When the train came, we knew the drill.
All six of us – an aunt, three sisters, and two brothers,
lined up with backs against the chain link fence
that ran for miles beside the track. We slipped
our fingers through the cold metal holes,
and grasped hard. Until our knuckles
turned white. We closed our eyes tight.
We waited, for a hot rush of air that swept our hair
up to the skies, and the horn that made
us deaf for twenty minutes after.
At the beach we sunned ourselves
like lizards, and burrowed our bodies
into the sand

Four Elements

More
The way you make me feel
More
Is what I believe
More
Is what you challenge me to
More
Is what I need.
Higher
The places you take me
High
Way up to you
High
The heart that beats me
High
Our lives, our truth.
Passion
The force that propels
Passion
Our reason for being
Passion
Call it whatever you want
Passion
Is more than a feeling.
Now
The time that we're living
Now
Can't pay for today
Now
This moment we live for
Now
The reason we're made.

DONNA FAITH

A Hollo-ween "Affair"

Ghosts and Goblins, Old Witches with brooms
 pass in the night as Halloween looms;
They're scary, wicked some can be mean
 as we travel at night to the Halloween scene.

Candles in pumpkins throw light after dark
 while shadows dance crazy in streets by the park.
There are spider webs hanging on skeleton bones
 and friendly ghosts, hiding near scary tombstones.

Werewolves are howling; the night is still young;
 whisper your words or hold on to your tongue.
Frankenstein lives in that house down the street
 where rickety boards moan loudly and creak.

We scream with shrill laughter in the dark night
 as everyone runs to the house with a light
 for a bag full of goodies, a handful of cheer,
 kool aid, hot chocolate or a glass of root beer!

Yes, it's Halloween night; there are parties in town,
 ghouls are out searching and strutting around.
While crows and big bats fly about in the street
 a car full of vampires scream out "Trick or Treat!

It's time for the little ones to be tucked in bed
 after running, laughing, and screaming with dread.
Their laughter and fun is mixed with a sad tear;
 It's a mighty long wait 'till another fun year.

CHERI M. BENTLEY-BUCKMAN

Broken Twisted Bicycle

driving my red jeep
in an affluent neighborhood
I saw a broken, twisted
bicycle,

near the curb
for several days
waiting

for the garbage truck
to haul it away.

bike was brown with rust
tires twisted like a snake,
had this bike been run over?

did a child have a fatal accident?
blood all over the pavement

bluebirds feel lonely.

SUSAN HOGAN

Strangers

We are strangers, passing on Dearborn, it's the lunch rush,
 we catch eyes: You smile
At my Metallica tee, but your suit restricts a comment.

MICHELLE MONSON

Ordinary Day

Thanks to another ordinary day
The sun came up just fine
The phone didn't ring to tell
Of daughters hauled off
Brothers institutionalized
Mammograms overdue
The cat came in for breakfast
The vase of flowers called out
its reviving aroma
The neighbors drifted by
to see if those oranges are ready
The mailman waved and bills arrived
The blue jay swooped for peanuts
We weren't bombarded with bad news
No killer bees, no earthquakes
We ate pumpkin pie, in bed,
The whipped cream placed just so.

By White

When it is time I step quickly,
following the white fox
into the snow's valley.

I can feel nothing in my limbs,
my heart beat slows,
the fox leads me through a birch forest.

I don't look back at the trail
where we have made no tracks,
see nothing but the ease
of fox – fur thick along spine.

I need no memories of a life
that was useful at one time,
and I trust in the valley and the fox
this direction after years

of trying many turns of mind
only to learn they all lead
to the white fox that has waited

on a mountain above a village,
as I follow the white fox
into the snow's soundless valley.

SONATA PALIULYTĖ

A Split Second of Hope

— translation by SERETTA MARTIN

A moment of hope
bounces back,
strikes, rebounds.
Now,
listen to the tingle of silence.
Tomorrow will come –
you need only to wait
for that next split
second – when
shades of dusk slice despair.

Vilties akimirka

Vilties akimirka
atsimuša ir vėl nutolsta.
Dabar
gali klausytis spengiančios tylos.
Rytojus bus –
tereikia tik sulaukti
akimirkos –
kai skrodžia neviltį šešėliai sutemos.

WILLIAM HAWKES

Somewhere Warm

In a dream, in a voice
fraught with veritas
the sage says a comet
full of magic must've
landed near that dragon,
referring to Peter, a poet
who once chided me
for writing a pretentious thing:
*"Both the temple and the garden
tremble in despair."*

Then it changes to a photograph
of five revolutionaries kneeling,
about to be shot. Four tremble
under sombreros, and one stares
ahead, proud, his sombrero set
on his heels. I hear him think:
is existence a gift, or does it teach
us to shun existence itself,
to chase desires no more into
this world of lies and illusion?

Plotinus said the Self is a flight
of the alone to the Alone,
and now a voice cold
as an asteroid says only other
than that of myself has journeyed;
I have never journeyed,
and I wake to an ordinary day:

Peter is dying of emphysema,
the sage and I suffered
a falling out, and somewhere
warm, trembling on a vine,
a grape wonders raisin or wine?

R. D. Skaff

3 a.m. Rendezvous

I wake to his loud tempo,
quietly scoot out of bed.
His rhythm remains.
No need to bother with slippers or a robe,
I'm heated just thinking about
who's waiting for me downstairs.

I tip-toe,
careful to skip
the step that creaks,
the one he still has not repaired,
through the hallway,

into the library.
I close the door, breathless,
pray he won't awaken,
realize I have left our bed, our room,
come searching for me –

Discover us under the covers
of thousands of quiet words,
making love, My Darling
Silence.

BOBBIE JEAN BISHOP

Mountain Haven

A short trip from the coast to
 recent snowfall, we hike a fire road
patched with ice. Bare trees,
 black with crows thrashing out winter
affairs, straddle slopes; our
 walking sticks gouge holes like eyes
that trail behind us, my own gaze
 seeking eccentricities of landscape in
shallow snow. Mud cemented to
 my shoes, I scrape them against a stump,
survey the white valley tiptoeing
 south. In the west tiny planets hover
cheek to cheek where gashes of
 sunset bleed purples and red, Nudging
my friend, I point to elegant Venus
 moored to a crescent moon. We turn
back from the path veiled in
 twilight ahead, surrender to a slow
decent, and our pending drive on
 a reluctant highway heading for home.

ANITA CURRAN GUENIN

Just a Song Again

The air brittle, sharp
against our hope-filled faces,
we wove an uncertain chain
toward the meeting house.

High heels made air holes
in crusty winter snow
allowing the earth to breathe,
release a marriage blessing.

Vows said, a Mozart concerto
matched our steps
down the ancient
aisle into a new life.

But sharp liar shards
excised the marital myth
cut the vital organs
killing the host of hope.

Even a forest
badly burned
takes time to forget,
muster courage toward growth.

Mozart's Andante
Piano concerto no. 21
in C major, lights
the room with bliss

I don't remember
it was my wedding song
Now, it's just Mozart
resurrecting himself again.

What I Learned at Bob Friend's Funeral

My grandmother's Christmas
casserole sits with the sad cold cuts.
No one eats.
Pat, his wife wears a dark
pink ruffled blouse,
guests give their hands
and mumbled words,
she gives them memories
and smiles.
I ask her how she is.
She takes my hand,
as though I am the
broken one,
smiling daffodilic
Grace she says,
child I woke up this morning
and Bob wasn't there.
And I could'a been real sad
about that. But instead
I just curled up next to his pillow
and thanked God in heaven
that for fifty-two years
and goodness knows
how many thousands a
mornings – he was.
He was there.
She rolls me,
a twenty-six-year-old baby,
in her arms.

I stand with the sad
cold cuts, try to wrap
my guts around her words.
'Cause I no longer believe
in fairy-tale
love. Yet, there it is.
Real as hiccups; heart attacks.

Alison S. Moreno

The Lunch Break Poems #3

squinting into sunlight
looking for those flinging bugs
weeds in the warm what
summer may have birthed
rising heat and poisoned eardrum
a slash from shoulder blade to waist
and a mouth full of dirt
a dead queen on the soles of
your feet and you said you loved
her like a sister
as your cigarette kissed her neck
because you weren't cool with
the rotation gracious time like
a cooling rack and some are just
greedy feeding their own monsters
handing over limbs of their
cellmates

To My Waning Self this Morning. . .

What if Michelangelo'd scrapped his scaffold,
 complaining of a sore back?
Or put off surgery of David from fear of piercing a vein?

One Rouen noon Monet might have moaned:
 "Roman Church: many views?"

What a shame if Rembrandt had given into darkness!

Verily sad, if Van Gogh had sighed:
 "Another iris among many. . ."
 Or failed to value the grains of his bed
 and homely chair. . .

Suppose Jean-François Millet'd surveyed his hay
 from a sleepy loft. . .
And Fitzgerald had overlooked youth's fascination with glitz
 so that Gatsby'd never been born. . .

Imagine Melville'd sung so many drunken sea chanties
 that Moby was just so much blubber. . .

What if Einstein'd surmised "It's just a thought."
 when phoning a relative?

Picture Pisa trashing its Tower because it leaned.
Beastly bad, if Benjamin Franklin'd "been burned"
 just "one too many times"
Or if the Wright Brothers fretted about being wrong?

What heartbreak, had O. Henry opined:
 he was just "another con."
Or, the Bronte's only brooded on the moors
 and Dickinson declined to write of hers – unseen?
What if McCourt had concluded
 he was just another *"Teacher"*
 Man, . . .
 And then, there's Handel.So, get a grip,
 your work might be Messianic.

<div align="right">

DIANA GRIGGS

</div>

My Moon Necklace

When I am dead my dearest
let the party begin
scatter my ashes north and south
as friends beat on their drums
I'll dance away on gusts of wind
and twirl along the ground.

When I am dead my dearest
fly to a Grecian Isle
visit the temple of Artemis
to laugh with the nubile maids
choose the one with downcast eyes
who stands alone in the crowd
protect her youth and budding breasts
with the gift of my crescent moon.

RACHEL GELLMAN

Poached

Your life is a cross between hard-boiled and scrambled.
You didn't go to Catholic school
and your weren't Bat Mitzvahed either.
No chorizo coagulating in your yellow mucus.
No fork poking at your yokes.
You weren't salted and peppered.
There was no milk mucking things up.
You were not poured into a pan,
forgotten, then scraped
and salvaged from the sides with a wooden spoon.
What's left of you is not resting in the sink
under a hot, soapy layer of resentment,
a voice from the next room screaming,
it's your turn to do the dishes.
You were poached, guided with two spoons
into a shape all your own.

In a town far away, a boy sits on a stoop,
his fingers tracing the stitches of a baseball,
his hand in the glove, sweating the leather,
eyes searching for his father.
His mother scrubs her scrubs in the toilet,
dreaming of her meth days,
no thoughts of him, or her lover
who is loving a man, pretending it's a woman.

Somehow you slipped
through the cracks,
unscathed,
but who is washing the dishes?

ELLEN WOLFE

Northern Divide

We stop on a road running straight
as a plumb line north to the Arctic Circle
as it splits a sea of trees stunted
by short summers and frozen soil.
No invitation here.

Our truck once a red flag of color
now spattered gray with wet snow
sits flattened beneath heavy clouds.
He is fleeing from a marriage.
I am looking for a life.
The damp air of the spring thaw
makes my bones feel restless, discontent.

With the departure miles ago
and our arrival distant,
we stand on a thin gravel shoulder,
suddenly human and vulnerable
in the quiet of this un-peopled immensity.

No pole or wire breaks the *otherness*
of this landscape, an infinity of dwarf pines,
stretching into the curved horizon,
a prehistoric sea retreating before us,
the great arced sky taking us up,
then releasing us into an emptiness
so complete, I am stilled.

Then we're back in the truck.
We drive on.

Regina Morin

Confetti Eggs

You know that Cafe on Charles Street,
where the tables are square white plastic,
and the floor is a garage floor grey?
You know that April morning,
when my egg was fried to look like
a folded linen doily,
and my bacon strips had
been sent out to be starched?
That day, there was a woman
with short grey hair at the
third table from the door
who brought the bouquet of her gaze
to the face of the sixty-something man
at her elbow, and never took her
hazel, love-like-a-fistful-of-lilies eyes
from his face. He bent and nodded
towards her long neck,
her gold button earrings above the green,
sleeveless sweater. My eggs were almost
cold when I returned to eat. My bacon strips
were leather thongs.
Her chin groped the air towards his.
Her long neck and straight nose were
pointed towards the magnetic pole of his stories.

Come to New Orleans, cher, sink into the
moment of that couple on the cusp of a love
affair. Dream of meeting the man in the moon
outside on the curb where flecks of colored feathers
are the confetti of promise.

DANIELA SCHONBERGER

On A July Evening

I later learned to love patios
the light on the patio the cigarette
on plexiglass, the leaning umbrella wrapped
into itself the way a Manhattan man, cold,
pulls his coat tight around his body
yes patios and empty bottles of Corona rattling
under the gusty shade and how I hate
scrubbing barbeque grill steak residue hardened
below two flies buzzing in tango
before I blast the hose water, I listen to
black dirt sit on rusted chairs, gossiping
about the marigold leaves and vines
blossoming slow and green along the railing
of the bench swing that creaks like an old song
and then with one right-hand twist of the metallic spout
all of it gets washed away, startling a *meow!* out
of the gray cat nuzzled against the windowsill.

MARLYS COLLOM

Scene from a Classroom Door

My son bearing messages,
his caught tears spilling,
has brought me to this place.
The silent hall amplifies my footsteps,
echoes my presence against the walls.

Entering the room, I feel more like
a witness called to the stand
than a judge. My youngest son is here,
seated in a too large chair,
his legs dangling in mid air.
He sees me and his face softens
at the touch of my smile.

There are other children here who are
familiar to me, except for their dimmed
brightness and their masked faces,
wearing pacifist eyes.
They sit tensely in their seven year old bodies.

The teacher stands at the front of the room,
her back as straight as a desert highway.
She is displeased and her mouth has become
a flame-thrower shooting words which burn.
Unaware of my presence,
she names the price to be exacted.
In the corner is a closet which reflects isolation,
emptied now – it waits.

Silently, I beg my son's forgiveness
for my delayed visit
and though he won't be here tomorrow,
my chilled hands clench into fists
knowing that the others must endure.

I watch this woman who has stumbled down
the clean, white pine stairs
of these children,
who has attempted to form them
into her own definition.

I pity her barrenness,
for not even the children's innocence
can absolve her.

MARTE BROEHM

Noble. Lonely. Late.

It's as if the night gives silence permission to speak,
black flowers open under a purpled moon
as when a long dream plunges you into the ocean,
but it's not an ocean, not a sea, but a shifting of
sense and nonsense, into.

It's as if beyond beauty's darkness is pleasure
as when warmth at the other side of the heart bleeds-
out next to music, the dance known by the dancing,
the music and wishing a star,
following a carpet over a mountain,
swimming in an ancient pool of Pompeii ruins.
It makes you happy,
the dance, the music, carpet and pool
even though the Mediterranean is full of ash.

LISA ALBRIGHT RATNAVIRA

"Excuse me, do you know where I am going?"

How will know when I get there –
how will I know when I am home?
I don't remember the address
the name of the street
but there was a yellow ribbon
around the oak tree in our front yard
baby birds lived in the arches
and sometimes they fell
out and blue bellied lizards waltzed
on my fence?
Did you see the turtle that rode
our pool sweeper?
My mom painted his shell
with her nail polish
so he wouldn't get lost.
Our dogs ate my color crayons
pooped rainbows on the sidewalk
by the pond that would freeze over
in the winter
my brother cracked it with a screw driver
and told me to trust him
walk over it "like Jesus"
I believed and fell.
I ate peanut butter and jelly sandwiches
topless on the patio
I need to find it
will the new family let me see my room?
I remember Dad's leather chair
and mom's plaid chair
I bet they are gone.

I saw a field where my brother and I
fed the horses carrots and sugar cubes,
if you could just help me find my way
you see I forgot my way home.

NANCY STEIN SANDWEISS

To Father

Shuffling slippers scratch pre-dawn silence,
wake me to your presence in the hallway.
Your sleep was never an easy grace -
always you wrestled consciousness to exhaustion,
awakening early, unsated but eager
for the wonders of the day.

Now illness has extinguished your gusto,
narrowed your vision, stilled curiosity.
Food repels, activity jars.
Your greatest pleasure the sting of hot water,
the shiver of ice chips on a parched tongue.

We eat together at day's end.
Your slow fork coaxes out seeds from pink flesh
as ruddy twilight fades to black.

Angels in Fallbrook

Mama, what do angels look like?

This, my small kiddo asks. In the throes of divorce. Of making a game of beans and rice. Of sorrow. Of innocent query and wonderment. This she asks, but how shall I answer? What can I say that would not be a lie passing my lips?

In the speckled dark of a sleepless, starry sky, I sit on our hill as she chases shadows in the warm breeze and a coyote pauses beyond the fence that separates us. The hill is ours because we love it. I think it loves us. It makes paths for us around rabbit holes, tarantula borrows, grainy mounds of queens and workers in constant toil.

I search for hope amidst the moonlit carpet of rabbit turds, brown and rich, the prickly stubble of deer grass, shaved by a peon's scythe, the manzanilla, its soothing ways unrecognized in the wild by those who buy it by the box.

The moon laughs at me and catches my girl, catches her dark curls and darker eyes, twirling into a glowing tornado, spiraling up toward the night, up into a future I fret I cannot affect, and my fear pulls her back to Earth. The coyote howls across the hill, and answers echo from a distant canyon. I peer through the grasses to watch her, stymied by impassable chain-link. A border to us, it cuts her world in half. And so she paces, her prey on the other side. And I chew a manzanilla bud, rub the tender skin beneath my skirt. The grass makes me itch. It makes me itch because I love to scratch. And so I scratch as I look out over our little town, ours because we scratch each other.

Why do I love it so here? How dare I raise my child in this place? This place of bitter anger and sweet Peruvian chocolate. Of testicle trees, our avocados, and shocking scarlet bottlebrushes. Of well-repressed, grey-green groves and lusciously chaotic words, wending their way behind closed doors, between tussled sheets, into fearful hearts. The heat of conflict radiates from our bodies, our beds, our lands, entangling the legs of a bawdy blend. And I wonder, what's not to love?

I lie in the dry grass, caressing the stars, eyes languid and wet, and I sense the loss of something, something I might not have ever wanted. The coyote, impatient with human encumbrances, glances at us and trots across the border, free to dine and commune with her own. My kiddo, delighted with discovering her ability to dance, moves deeper into the dark.

Angels? I call.
Oh, never mind, Mama. I just saw one!
And she spins, spins into the sweeping night. Soars out of reach. She is gone. Gone.

FEATURED POET

STEVE KOWIT

Deciphered
from an Ancient Tablet of an Unknown People

We found the land inhabited by no one but nomadic savages
who groused and caviled in a language barbarous & dissonant—
unlettered tribes pretending that they did not understand us
when we told them that the Lord Beyond Ten Thousand Suns
had given us this land they thought was theirs. That we
were foreigners while they had lived here for a thousand years
meant nothing. Rikshav Jahvuht, the One True Deity, had spoken.
At first, however, seeing how things stood,

 we kept our latter purpose
to ourselves, moved warily among them, were dutiful, compliant
neighbors while our reinforcements quietly made port.

 Our numbers
grew. Only then we struck—harrowing the ground with corpses,
seizing that which sharpened sword and holy writ affirmed

 was ours.
Abroad, our brethren broadcast everywhere our sacred cause,

 saw to it
those who were opposed to our ascendancy were outmaneuvered,
silenced, shouted down. That tens of thousands of those savages
who would not cede their land to us were slain, & that their towns
& farms eventually were ours,

 & that the remnants of that desert race
were then peremptorily expelled, remains—it hardly need be said—
their fault entirely. Humble servants of Rikshav Jahvuht, we long for
nothing if not peace: that we might plough these fields that

 uncontestedly
at last are ours, & build our sacred nation-state upon this ground
which, in his everlasting glory, mercy, love & unrelenting wrath

 against
His enemies & ours, the Lord Beyond Ten Thousand Suns has

 given us.

Iraqi Child & Occupation Soldier

– a photograph by PETER TURNLEY

The left half of the photo is the soldier's back, a shot
from just behind his camouflage fatigues, there
where a black machine gun with its mounted scope
is clipped at his belt. The girl (eleven, twelve?),
glowers up at him with a ferocious loathing, a gaze
so black with rage that everything she dare not say
is thereby said. Across the road, a thin young man
in white (father, older brother?), his lips a nervously
accommodating grin, arms dutifully outstretched,
is being patted down by yet another helmeted factotum
of the occupation army: 17th Brigade, Blackwatch
Regiment: those desert rats who had been gulled
into believing they'd be greeted by beflowered jubilant
Iraqi peasants dancing in the streets. Now refugees,
the child and her family are fleeing Basra, fleeing tanks
& smoke & gutted houses, corpses hideous along the road,
& are passing, at the instant Peter Turnley's camera
captures her, a checkpoint on the southern outskirts
of that city. To the right, the gloved hand of an unseen
adult grips the child's, unequivocally intent
on pulling her along – so that the girl will not long
stand there, glowering at that soldier; though in fact,
because it is a photograph, she will. As in the utmost
suffering, of which the heart can hardly be expected
to let go, the moment of this child's malediction
shall not pass: this image, then, itself a kind of Hell
in which that agent of the imperial West will stand
accused before her till all human history
has vanished – harrowed by the sting of her eternal wrath.

Endearing

Listen, I know he's a reputable poet, but when
in the course of that piece for his wife he watches
her out in the yard plucking bugs from her plants
& pinching them till they burst, I winced.
No doubt he imagines it's part of the charm
of that scene of his wife tending her vegetable patch,
that the indifferent act of squeezing to death
those little creatures who also, like us, have only
one life, is endearing. The rest of the poem is a blur.
Though I vaguely recall in the last line or two
that later, in bed, his wife's lips are fragrant
with nutmeg & ginger. You know, that sort of thing.

Neighbors

When he noticed four teenage kids from the Mission School
lugging boxes out of Marion's house, he phoned
& she told him that escrow had closed a week early.
She'd be gone by late afternoon. Well in that case, he said,
he would drop right over to say goodbye. But she said no, don't.
Everything is just too chaotic, too rushed. She was packing
the last of her things. Well then he would phone her, he said,
at the new place, the trailer court out in Spring Valley near
the hospital she had to be close to, & he would drop over
for tea once she had settled in. Oh that would be lovely,

 she said,

& thanked him for everything he & his lovely wife Mary
had done, for all of their kindness. She said she would miss
them, & she needn't tell him how much she would miss
this wonderful house up here in Potrero. You can well imagine,
she said, how hard it is going to be to. . . & for a long moment
they were both silent, the man who himself was no longer

 young

& the elderly widow with her modest, intelligent grace,
whose slender body was rapidly coming undone. The last time
he'd visited her she'd been enveloping all of her life's precious

 photos

to send to her niece in Ohio. Now the man stood in his own

 kitchen

listening to Marion's voice on the phone & looking out at her

 house

to the north of his own, & looming behind that house that was
suddenly no longer hers, at the high desert chaparral hills. Then
she thanked him again & fumbling slightly for words they said
their final goodbyes, quietly, with the awkward reticence of

 friends

who understand they may well never see each other ever again.

POETRY WITHOUT BORDERS

POESÍA SIN FRONTERAS

BILINGUAL SECTION

EDITORS
Olga García
Edith Jonsson-Devillers
Megan Webster

ROBERTO CASTILLO UDIARTE

La Cebolla Silvestre

– pa'l RÓBER L. JONES

Esta noche que empieza a hacer viento te recuerdo, carnal,
en la *24th Street* y afuera estacionado tu viejo *Rambler* color verde
con una antigua máquina de coser Singer en el asiento trasero,
frente una casa donde se atendían a alcohólicos y viejos
\qquad drogadictos,
un barrio lleno de latinos y negros y hombres solos y *homeless*
y constantes sirenas de patrullas y aviones bajando rumbo al
\qquad aeropuerto;
a unas cuadras el billar *Four Corners* donde solíamos ir a jugar
\qquad bola ocho;
cerca una licorería atendida por gente de Irak o el Líbano,
\qquad nunca lo supimos;
y a otras cuadras, el maravilloso lugar llamado *Big Kitchen*, donde
\qquad servían
los mejores y más baratos desayunos de todo el condado de San
\qquad Diego.

Esta noche de principios de otoño te recuerdo, carnal,
caminando por los pasillos de tu casa de madera crujiente de vieja,
las paredes llenas de libros de poemas y fotografías en blanco y
\qquad negro,
el viejo tocadiscos siempre encendido tocando música de *Miles
\qquad Davis,*
Carla Bley, los *Allman Brothers, John Fahey,* la *Janis* y *Dylan* y *The
\qquad Band;*
montañas y más montañas de revistas, libros, periódicos y discos
\qquad de jazz;
la televisión prendida sin volumen en un juego de béisbol de *los
\qquad Padres,*
la cocina oliendo a pozole, orégano, limones y cebollas recién
\qquad cortadas,

el refrigerador lleno de cervezas mexicanas, gringas, japonesas y
alemanas,
el teléfono timbrando cada quince o veinte minutos todo el día
y la noche.

Esta noche de septiembre te recuerdo, carnal,
con tu cabello güero medio largo y la calvicie prematura,
tu cuerpo como un oso de ojos azules, leyendo, a grandes
pausas,
tus poemas tan humanos y gringotes traducidos al español por
ti mismo,
donde hablabas de tu abuelo *Ashley* cuando salió del
manicomio;
de tu tío William, el peluquero; de tu madre y otras bellas
mujeres,
Jenny, Linda, Patricia, Julieta, Annie, Elise, Paula y la enana *Emma
Cobb,*
la que te rentaba un lugar donde dormir en el pueblo de
Kalamazoo;
y también contabas de los amigos entrañables como el *David* y el
Jeffrey,
y de la señora depresión, del *mikeys big mouth, mister gin* y el *señor
cuervo.*
Esta noche de música infinita, carnal,
recuerdo las fiestas interminables en tu casa que se volvía una
embajada
con las amigas y amigos que llegaban de Mexicali, Los Ángeles,
Tijuana,
Fresno, el Deefe, San Francisco, Guadalajara, Nueva York y puntos
intermedios, y las conversaciones eran en inglés y en español,
en señas y *espanglish,*
y los temas brincaban de la literatura al cine,
de la música al juego de béisbol,
de los gobiernos reaccionarios al *grafiti,* de las revistas literarias
al amor,
y todos los cuartos eran los mismísimos cuartos de la mítica Torre
de Babel
donde surgían proyectos de nuevos libros y antologías que nunca
fueron,

pero nacían nuevas amistades y en algunas ocasiones romances
pasajeros.
Esta noche de nostalgia con el cielo estrellado, carnal,
recuerdo las interminables noches que pasábamos juntos
traduciendo,
luchando con los diccionarios para encontrar las palabras
perfectas,
los garabatos en decenas y decenas de hojas de *block*, amarillas y
blancas,
los sinónimos y antónimos que nos recordaban algunas viejas
canciones
y poníamos los discos de *Dylan, Terry Allen, Leonard Cohen* y *Joni
Mitchell*
para descubrir las metáforas que fueran exactas al español o al
inglés,
de los textos de *Mark Strand, Josécarlos Becerra, Galway Kinnell* o
Sabines,
las discusiones hasta que aparecía el sol y tú y yo, borrachos y
contentos,
nos dábamos un pase y prendíamos un cigarro por el poema ya
traducido.

Esta noche de sentimientos en remolino, carnal,
te recuerdo porque celebrábamos los cumpleaños juntos el mes
de febrero,
yo el siete y tú el ocho, la misma fecha que mi padre y el mismo
nombre,
y yo ya había decidido adoptarte como el hermano mayor que
nunca tuve,
y ahora éramos hermanos de acuario, de música,
de pasiones y de literatura,
y nos regalábamos discos, libros,
botellas de vinos tintos y tequilas blancos,
y nos íbamos a los conciertos de *Herbie Hancock, Chic Korea* y *Keith
Jarret,*

nos dábamos consejos de carnales y llorábamos las desgracias
amorosas,
y la *Janis* y la *Billie Holliday* nos acompañaban hasta que
amanecíamos
y el nuevo día nos recibía de nuevo con el aromático café de la
esperanza.

Hoy recuerdo aquella noche de eclipse lunar, carnal,
del 26 de septiembre del 96 cuando alguien te encontró en la
calle,
en el centro de San Diego, y nadie te reconoció en la oscuridad,
nadie supo que eras el hombre que hacía el pozole más sabroso,
que eras el amo del *Toulouse,* el perro más apestoso de todo el
barrio,
que eras el más silencioso de los vecinos de toda la zona centro,
que manejabas el carro más lento de todos los *freeways* del
condado,
que eras el mejor poeta de ambos lados de la frontera Tijuana–San
Diego
y que escribías los poemas más humanotes, más amorosos, más
Jones.
Dondequiera que estés, este tequila va por ti, carnal, ¡salú!

Robert L. Jones (1945-1996), poeta, maestro, traductor al
inglés de la poesía de Juan Sabines, José Carlos Becerra y
otros poetas mexicanos, amante de la música y de largas
conversaciones. Su libro **Wild Onion** fue ganador de un
premio nacional de poesía y, posteriormente publicado en
México en una ediciòn bilingüe.

Wild Onion

—for Robert L. Jones

—*translation by* Daniel Charles Thomas

Tonight, when the wind begins to blow, I remember you, bro,
on 24th Street with your old green Rambler parked outside
with an old Singer sewing machine in the back seat,
in front of a rehab house for alcoholics and old drug addicts,
a neighborhood full of latinos and blacks and lonely men and
 homeless
and ever-constant sirens from cop cars and airliners descending
 toward the airport;
a few blocks from the Four Corners poolhall where we used to
 go play 8-ball;
near a liquor store staffed by people from Iraq or Lebanon,
 we never found out;
and a few blocks more, the marvelous place called Big Kitchen,
 where they served
the best and cheapest breakfasts in the whole county of San
 Diego.

Tonight, at the beginning of Autumn I remember you, bro,
walking the hallways in your house of old, cracked wood,
the walls full of books of poetry and black and white
 photographs,
the old record player always playing music by Miles Davis,
Carla Bley, the Allman Brothers, John Fahey, Janis and
 Dylan and The Band;
piles and more piles of magazines, books, newspapers and jazz
 records;
the television lit up with the volume off for a game of Padres
 baseball,
the kitchen smelling of pozole, oregano, lemons and freshly cut
 onions,
the refrigerator full of Mexican beer, American, Japanese, and
 German,

the telephone ringing every fifteen or twenty minutes all day
and night.

This September night I remember you, bro,
with your half-long blonde hair and premature bald spot,
your body like a bear with blue eyes, reading, with long pauses,
your poems so human and gringo-ish you yourself translated
into Spanish,
where you speak of your grandfather Ashley when he got out
of the asylum,
of your uncle William, the barber; of your mother and
other beautiful women,
Jenny, Linda, Patricia, Julieta, Annie, Elise, Paula and
dwarfish Emma Cobb,
she who rented you a spot to sleep in the town of Kalamazoo;
and you also talked about your deep friends like David and
Jeffrey,
and Lady Depression, of Mikey's Big Mouth,
Mister Gin and Señor Cuervo.

Tonight, with infinite music, bro,
I remember the endless parties in your house that became an
embassy
with all the friends who came from Mexicali, Los Angeles,
Tijuana,
Fresno, Mexico City, San Francisco, Guadalajara, New York
and points between,
and the conversations were in English and in Spanish,
in gestures and Spanglish,
and the subjects leapt from literature to film, from music to
baseball,
from reactionary governors to graffiti, from literary magazines
to love,
and all your rooms were the very same rooms of the mythical
Tower of Babel
where projects were born for new books and anthologies that
never were,
but gave birth to new friendships and sometimes to passing
romances.

This nostalgic night with the starry sky, bro,
I remember the endless nights we spent translating together,
struggling with dictionaries to find the perfect words,
the scribbling on dozens and dozens of block pads, yellow and
 white,
the synonyms and antonyms making us remember some old
 songs
and we put on the records of Dylan, Terry Allen, Leonard
 Cohen and Joni Mitchell
to discover metaphors exactly equal to Spanish or English,
from the texts of Mark Strand, Josecarlos Becerra, Galway
 Kinnell or Sabines,
the talking until the sun came up and you and I, drunk and
 happy,
did a line of coke and lit a cigarette for the poem now
 translated.
Tonight, with feelings in a whirlwind, bro,
I remember you because we celebrated our birthdays together in
 February,
me the seventh and you the eighth, the same day as my father
 with the same name,
and I had now decided to adopt you as the big brother I never
 had,
and now we were brothers of Aquarius, of music, of passion and
 literature,
and we gave each other records, books, bottles of red wine and
 white tequila,
and we went to concerts by Herbie Hancock, Chic Corea and Keith
 Jarret,
we gave each other brotherly advice and we wept over love's
 misfortune,
and Janis and Billie Holliday kept company with us until we
 woke up
and the new day received us again with the aromatic coffee of
 hope.

Today, I remember that night of the lunar eclipse, bro,
on the 26 of September of 96 when someone found you in the
 street,

in downtown San Diego, and no one recognized you in the
 darkness,
no one knew you were the man who made the most delicious
 pozole,
that you were the master of Toulouse,
 the most stinking dog of the whole neighborhood,
that you were the quietest of all the neighbors in all downtown,
that you drove the slowest car on all the *freeways* of the county,
that you were the best poet on both sides of the Tijuana-San Diego
 border
and that you wrote the most gigantically human, most loving,
 and most Jones poems.
wherever you may be, this tequila is for you, bro, salud!

ROBERT L. JONES (1945-1996): a poet, teacher, translator into English of the poetry of Jaime Sabines, José Carlos Becerra and other Mexican poets, lover of music and of long conversations. His book **Wild Onion** won a national poetry award and was later published in México in a bilingual edition.

En Quechua

La noche, dormilona ave de tempestades
y yo,
sueños de arrumacos entre chilcas
donde cualquier transeúnte no pueda jamás ver.

Me adormece el canto quechua de mi nana.
En quechua, mis amores se pierden para siempre.

Ayayay,
frases que descifran el sosiego de mi alma media ausente.
Rucu, rucu, arrurrú,
me adornan los oídos tus relinches de joya tintineante.
Adormece ya mi amorrrr. . .

Hace años que no llevo
la barriga llena y el corazón contento.
Hace siglos que no maman,
que no – hombre, que no nombre,
tú, Pachamama.

Y cuando llega a casa se desnuda y anda libre por ahí.
Pilarcitos de amores secos salen de mis medias,
terrones de empanadas de viento decoran mis calzones.

Rucu, rucu,
se elevan hasta el aire,
Rucu, rucu,
revolotean en mi nariz.

A, B, C, Des-a- parecen apenas las veo.
En quechua, tras la chilca.

In Quechua

– translation by LAURETTE GODINAS *and the editors*

The night, that sleepy bird of tempests
and me,
dreams of *arrumacos* amongst *chilcas*
where no passer–by will ever see.

I doze off hearing my nanny sing.
In Quechua, my loves are lost forever.

Ayayay, phrases decode the peace of my partly absent soul.
Rucu, rucu, arrurrú,
your neighs like tinkling jewels adorn my ears.
Fall asleep, my love. . .

I have not had for years
a full belly and a merry heart.
It's been long since they have sucked,
since they no–man, since they no–name
you, *Pachamama*.

And when she gets home, she undresses and wanders freely
around.
Little stems of "dried loves" come out of my socks,
clods of "wind pies" adorn my panties.

Rucu, rucu,
they rise up in the air.

Rucu, rucu,
they flutter my nose.

A, B, C, Disappear as soon as I see them.
In Quechua, behind the *chilca*.

arrumacos: endearments.

chilca: small bush with bitter sticky leaves, typical of the Andean region.

Rucu, rucu, arrurrú,: rucu means"old" in Quechua, and *arrurrú* is a typical expression used in lullabies.

Pachamama: mother Goddess of the Inca, Creator of Heaven and Earth.

Amores secos", "dried loves" (*Acaena splendens*) are plants whose spiny fruits adhere to hair, clothes, etc

"*Empanadas de viento*", "wind pies" are typical Ecuadorian pastries filled with cheese, onions, and sprinkled with sugar.

En Los Esteikes Senaikes

En Los Esteikes Senaikes barren dinero, Tía.
Mijo, no barren nada.
O, sí tía!
ya me voy a los Esteikes Senaikes.
Me pongo mis Levis y le doy un abrazote
a Mickey Mouse.
Tía, ven conmigo.
Bautízate en el Río Bravo
Nos Vamos a hacer millonarios, Tía
En Los Esteikes Senaikes.

In the United Steaks

– translation by the author

In the United Steaks, people sweep money off the streets.
Sweetheart, don't be silly, they don't even sweep up dust.
O, yes, Auntie!
I'm going to the United Steaks.
I'll wear my Levis and give a big ole kiss
to Mickey Mouse.
Come with me, Auntie.
Baptize yourself in the Río Bravo.
We're gonna be millionaires, Auntie, over there,
in the United Steaks.

(Libertades)

Pero nos cortarán la luz
para recuperar las cenas a la luz de las velas

Pero nos cortarán el agua
y así nos beberemos mutuamente

Pero nos echará a la calle el terrible casero
se quedará con los muebles
los gatos y los perros
para que sin cadenas respiremos el aire
y ningún techo estorbe el firmamento espléndido
ni el sol del mediodía nos encuentre en la cama

Pero nos llegará una carta desde el buró de crédito
y andaremos descalzos por las calles
para que el frío de invierno nos lave los pecados

(Liberties)

– translation by the author and the editors

But they'll turn off the power
so we recover candle-light dinners

But they'll turn off the water
and so we'll drink each other

But the terrible landlord will throw us out on the street
and he will keep the furniture
our cats and dogs
so we may breathe the air without chains
and no roof will obstruct the splendid firmament
nor the noon sun find us in bed

But there will come a letter from the Credit Bureau
and we will walk barefoot on the streets
so the winter cold may wash away our sins

JOSEFA ISABEL ROJAS

Versiones Del Atardecer Mojado

1
Fue la tarde una paloma desnudándose
y la lluvia dejándose venir
me recordó tu lengua

2
Toda la tarde ha llovido
(la tarde no llueve:
es llovida
La lluvia atardece:
y es atardecida)

3
Yo te quemo y empapados
vemos toda la tarde
la lluvia
sobre el árbol de durazno

Wet Sunset Versions

– translation by ALFONSO GARCÍA CORTÉS

1
The afternoon was a dove getting undressed
and the rain letting herself come
reminded me of your tongue

2
It has rained all afternoon
(the afternoon doesn't rain:
It's rained on
The rain afternoons
and is afternooned)

3
I burn you and, both soaked,
all afternoon long we watch
the rain
on top of the peach tree

Canción De Amor Del Tiburón Blanco

Las constelaciones danzan alrededor de nuestro abrazo.
Nuestros pechos brillan. Bailemos este juego, el altar de tu
cuerpo, comulgo sobre él. Alegría a dentelladas. Necesito
prenderme de tu boca para convertir este caldo fresco en
mar de juego inmarcesible. Entras en mí, decantamos los
arpegios del músculo. Aromatízame. Me aferro, muerdo,
canto, sueño pegadita, te huelo y sé ya de dioses y
divinidades efímeras. Saltamos abrazados sin brazos,
 somos el recuerdo de las colisiones
primigenias, de cuerpos estelares en el mero origen del
orgasmo. Callemos y escuchemos nuestro corazón. Unámonos,
canta tu gloria y sueña eternamente en mis entrañas.

White Shark Love Song

– translation by the author and the editors

Constellations dance around our embrace. Our chests shine.
Let us dance this game.
I receive Holy Communion on the altar of your body. Biting
joy. I need to anchor myself to your mouth to turn this fresh
wine into a sea of imperishable fire. As you enter me, we'll
decant arpeggios of muscle. Perfume me. I seize, bite, sing,
dream close to you, smell you in the aura of ephemeral gods
and divinities. Embraced, we jump without arms. We are the
memory of primordial collisions, of stellar bodies at the
inception of orgasm. Let's listen in silence to our hearts. Sing
your glory to me, and forever dream in my entrails.

FRANCISCO BUSTOS

eso que siento when your
voice swims to my ears

Can't find the right words
como explicar la semilla de tu voz
those eyes, that voice,

donde están las palabras exactas
exactly what?
beautiful existence? alegría?
tu llenas al mundo
sweet voice que hipnotiza
endless smiles sin llanto
can't explain asi nomás
eso que siento when your voice swims to my ears
can't explain asi nomás
eso que siento when your eyes open and greet the sun
can't explain asi nomás
eso que siento when my mind floats to you

that, what i feel cuando nada
tu voz hacia mis oídos

– translation by the author

No encuentro las palabras exactas
how to explain the seed of your voice
esos ojos, esa voz,
where are the exact words
¿exactamente qué?
¿bella existencia? joy?
you fill the world
dulce voz that hypnotizes
sonrisas interminables that never cry
cómo explicar, just like that
that, what i feel cuando nada tu voz hacia mis oídos
cómo explicar, just like that
that, what i feel cuando tus ojos abren y saludan al sol
cómo explicar, just like that
that, what i feel cuando flota mi mente hacia ti

Premonición

Hablo de la fragilidad de la dicha.
Del hilo de araña que tornasol pende
y poco a poco teje luz en la penumbra.
Filo, embriaga la oscuridad como un relámpago.
Hablo de la voz
que gota a gota resbala sudor,
estalla rocío;
espejo se enraíza aroma.
Préndese peine.
Hebra a hebra separa tiempo la ponzoña
del cansino vuelo
sin ton ni son
de la jornada peregrina.
Hablo de las manos que oráculo reptan pétalos.
Distantes efímeras mariposas
primavera bailan
arista lejanía.
Habla límite el verano.

Premonition

– translation and adaptation by the author and MEGAN WEBSTER

I speak of the frailty of bliss,
of the iridescent spider web thread that lures,
and weaves light stitches in the shadows.
Threshold, it entices darkness as swift as lightning.
I speak of the voice.
Drop after drop, it sprinkles onto a sweat
bursting into dew.
Its scent roots you to a mirror;
comblike it clings to your head…
Strand after strand, in time, it eases the spite
of the idle flight,
the graceless rhetoric
of any other day.
I speak of oracular hands that ripen into petals.
Distant ethereal butterflies,
they spin into Spring's jazzy
faraway curb.
Summer, finally, sounding out its ending.

Inspección Secundaria /
Secondary Inspection

I
Hoy tampoco limpié mis zapatos.
Dejaré el lodo de mis botas esparcido en los caminos divididos.
Lodo aquí, lodo allá.

Ya llegó el gusano rojo con su *sweetly* tañer de campanas.
Cuando voy dentro del *Trolley* me gusta leer repetidamente
la palabra: *Sand*. Me gusta repasar las imágenes de cruce:
nacionalidades,
colores de piel. Acentos sonoros de lenguas: Rasgos.
¿A qué vas a San Diego?¿A qué dirección te diriges?
¿Tienes otra identificación?¿A qué te dedicas?¿Dónde vives?
La respuesta no está en el viento, querido Bob.
La respuesta tiene que ser: *shopping, shopping, shopping.*
Que no es igual a *chopping*, por ejemplo:
$$\text{"She chops wood for fire".}$$

El verbo entrar. El verbo salir. El verbo cortar.

O fragmentar.
Una nube densa, un cúmulo – allá arriba –
se encuadra tras la ventana mientras cruzo la estación
Palomar Street.
Es el momento justo cuando recuerdo la escritura onomatopéyica
de un abrazo.
Es el momento justo cuando veo las bardas invadidas
de flores azules
Quiebraplatos-Morning Glory: Ipomoea.
Es el momento justo cuando el bebé que lleva la señora
en el asiento de enfrente
comienza a reír. Y todos los locos consumidos dentro
del vagón despiertan.

II
Hierbas perennes pero *Leaves of Grass*:

Come, said my Soul, escribió Walt.
Come, as you are, as you were, cantó Kurt.
Where Dreams Come True, dijo el otro Walt.
In the Realms of the Unreal, dibujó Henry Darger.

(Inspección secundaria)

¿Conoces mi país?¿Hablas español? ¿Lees los
periódicos?¿Crees todo lo que ves en la televisión? ¿Cuánto
cuesta vivir allá, aquí? ¿Cuánto cuesta vivir en ningún lugar?
¿Seguimos todos sordos y ciegos?
¿Tienes miedo? ¿Te gusta cuando los perros te olfatean?
¿Todos tenemos miedo?
En la novela 1984 George Orwell escribió:
LA GUERRA ES LA PAZ LA LIBERTAD ES LA
ESCLAVITUD LA IGNORANCIA ES LA FUERZA
¿Sabes a qué se refería?

III
(*She chops wood for fire*)

Cuando voy dentro del *Trolley* me gusta leer.

Me gusta tocar repetidamente la palabra *Sand*.
En español significa arena.

Secondary Inspection / Inspección Secundaria

—translation by TYLER DAUGHN *and the editors*

I
Today I didn't clean my shoes either.
I will leave the mud of my boots scattered in the
 divided streets.
Mud here, mud there.

The red worm arrived just now, *sweetly* tolling its bells.
When I'm in the *Trolley* I like to repeatedly read
 the word: *Sand.*
I like to recall the images of crossing: nationalities,
color of skin. Accents, sounds of tongues: features.
Why are you going to San Diego? What direction
 are you going?
Do you have any other identification? What do you do
 for a living? Where do you live?
The answer is not in the wind, dear Bob.
The answer has to be: *shopping, shopping, shopping.*
It's not the same thing as *chopping,* for example:
 "She chops wood for fire."

The verb to enter. The verb to exit. The verb to cut.

Or to fragment.
A dense cloud, a cumulus—up above—
The window frames it while I cross Palomar Street station.
It's just the moment when I remember the onomatopoeic
 spelling of an embrace.
It's just the moment when I see the blue flowers
 invading the walls
Morning Glory—*Quiebraplatos*: Ipomoea.
It's just the moment when the baby being held by the
 woman on the front bench
starts to laugh. And all the insane consumers in the car
 wake up.

II
Perennial grasses but *Leaves of Grass*:

Come, said my soul, wrote Walt.
Come, as you are, as you were, sang Kurt.
Where Dreams Come True, said the other Walt.
In the Realms of the Unreal, drew Henry Darger.

(Secondary inspection)

Do you know my country? Do you speak Spanish? Do you read
the newspapers? Do you believe everything you see on television?
How much does it cost to live there, here? How much does it cost
if you live nowhere?
 Will we all remain deaf and blind? Are you scared?
Do you like it when the dogs sniff you? Are we all scared?
In the novel "1984" George Orwell wrote:
WAR IS PEACE LIBERTY IS SLAVERY IGNORANCE IS
 STRENGTH
Do you know what he was referring to?

III
(She chops wood for fire)

When I'm in the trolley I like to read.

I like to repeatedly touch the word Sand
which in Spanish means *arena*.

Radio Purga

De golpe suena el guitarrón. Así revienta el verbo de palenque y
flequillos.y aparece este charro estelar despachando alebrijes
de inglés inocente.
No se puede esperar lo que no se espera. Así que decrezcan los dos
polos de lonja y dopaje y acabaremos con las tallas de guitarrón y
las marcas mundiales, y aquellas infelices mañanitas nocturnas.
Gringos a creces acostumbrados por el crack y el pop del valor
inflado, por la flaqueza de conceptos abiertos, por el feng shui
feriado por todas las tierras, lenguas y estaciones liquidadas, por
la moda retro de medias solitarias y manoplas agujeradas. Claro,
a pesar de todo, esta tarde plebe hay obsequios corrientes,
hora feliz y karaoke chiflado.
Cada vez más los verbos son así, astros inmovilizados,
celulares de
chapopote lavado. Por la baja autoestima del éter se dan las rebajas
de generación. Así del interés alto en grasa nace el arte lipo, del
culto lite el jogo descremado, de la farándula encuerada así el reality
del auto-secuestro y de la fiebre del mitote comprometedor el hollín
auto-actualizado, el come back como manda. Así escribimos este
verso poco económico, una hoja seca que menta un survivor
patrocinado por extractos de satori, açaí y néctar de stevia que llega
a este alebrije de poco foco, un iceberg carioca cada vez más
como arte lavado.

Purge Radio

– translation and adaptation by the author

A guitarrón reverbs without. This verb's palenque and
bantam bling rapping out like this. Fronting before you this
charro soap stud mountebanks the naïve art of English.
One cannot wait on want. Let the bipolar diets of love handles
to doping redux and we will purge all guitarrón sizes, world
stamps, ungodly serenades. The world grows green goes used
to the crack and pop of the house vacuum, to the lean
constitution of open concepts, to the lay away feng shui
shebang of lands, tongues and seasons liquidated, to the retro
trend of single stockings and riddled mitts.

Come, despite the present above the above at dusk we will gift
at the usual happy hour the shabby chic door prize to draw
your lot before the hapless karaoke.

Still verbs have their way, frozen stars to tar washed cells. Just
so the ether's rock bottom self-esteem rises to this pitch in
generation. Out of the fatty rehab interest realizes this art lipo.
From a cult bent on lite reduced jogo, out of nude scenes the
self-spiriting away of reality show downs, in damning rumors
self-actualized smut, the comeback plight de riguer. This is
one way to overwrite spent verse, a dry leaf on survivor
unplugged bringing you extracts of satori, açaí and the essence
of stevia docking at an artless chimera of uber obscure focus.
The more we speak amazonian icebergs grow mean and base
<div align="right">as laundered art.</div>

Elogio A Los Desamados

El amor susurra, ríe, sacude, traiciona,
festeja, envidia, auxilia, obstaculiza, todo lo puede,
afianza la Necesidad insaciable
pero sobre todo
injerta en sus víctimas el vicio de la convivencia

Benditos desamados míos,
jamás lograrán abrir mi convaleciente herida
ni ahondar congénito mi desconsuelo
ni desgajar el desconcierto con el que resiento la vida

Un desconocido no agita la nostalgia del plumaje habitual
de domingo
ni zozobra tus anhelantes sueños ni cruje con la punzada
de poseer o ser
poseída; ni ofende ni decepciona ni exige
no clama venganza o sumisión rencorosa
ni agrieta tu hambre, tu sed ni serena ni desconsuela

El amor cobija, es témpano, es condena y absolución perpetua
En el mejor de los casos, misterio,
pero sobre todo
es culpa

benditos desamados desconocidos
ignotos míos
jamás lastimarán mi quebrantable espíritu
ni romperán mi flaco corazón en mil pedazos

Elegy To The Unloved

– translation MEGAN WEBSTER

Love whispers, laughs, shakes, deceives,
celebrates, envies, aids, impedes; it can do anything,
it guarantees insatiable Need
but above all
grafts into its victims the vice of coexistence.

My blessed unloved ones,
you will never open my convalescing wound
nor deepen my inborn grief
nor unlock the bewilderment with which I resent life.

A stranger will not ruffle the nostalgia of habitual
 Sunday feathers
or upset your longing dreams, or dislodge the itch to possess
or be possessed; or offend, deceive, or demand;
neither will it clamor for vengeance or rancorous submission,
nor break your hunger, your thirst, nor calm or grieve.

Love mantles, is an ice block, a sentence and
 perpetual absolution;
in the best of cases, a mystery,
but above all
it is guilt

blessed undiscovered unloved ones,
my unknown ones
you will never hurt my brittle spirit
or break my lean heart in a thousand pieces.

imágenes

estas sombras salvajes
salvadoras
me chiflan desde lejos
desde allá
más allá
por donde viven fantasmas
e ideas
y filosofía
y piel
y hueso colorado
sangre mezclada
descansando en charquitos
en el piso
donde pegan los tacones
y arrastran las plantas bailadores
al ritmo de la banda
amantes se abrazan debajo una luna llena
que brilla ojos dañinos
labios mojados y hambrientos
almas arrimadas a una barra
un trago de tequila en mano
suspiran, un brindis
caen lágrimas adentro
y gritan a los cuatro vientos
chiflan a los perdidos
como yo
parado en el horizonte
nada más que un extranjero
pero me saludan
desde allá, más allá

estas imágenes
estas sombras
estas memorias
frías como fierro
balanceadas como una navaja
me llaman
a mí

images

– translation by FRANCISCO BUSTOS *and the editors*

these wild shadow
saviors
whistle at me from afar
from over there
más allá, way beyond
where ghosts live
and ideas
and philosophy
and skin
and red bone
mixed blood
resting in small puddles
on the floor
where high heels stomp
and dancing foot plants drag
to the rhythm of la banda
lovers embrace below a full moon
which shines harming eyes
wet, hungry lips
souls leaning against a bar
a trago of *tequila* in their hand
they sigh, un brindis

tears drop inside
and they scream to the four winds
whistle to the lost ones
like me
standing on the horizon
just a foreigner
but they salute me
from over there
más allá, way beyond
these images
these shadows
these memories
cold like steel
balanced like a razor blade
keep on calling
me

<div align="right">

ELIA CÁRDENAS S.

</div>

Laúd

Lamentos de laúd
Pululan la noche
Emergen agónicos sonidos
Mezclados con el rumor de las olas
Lanzan su gasa blanca
Sirven de esparadrapo a tus heridas

Por sesenta años navegaste, sorteaste
Incontables peligros
Quelonio vencedor,
Este día te abandonó la suerte

Dolor inmerecido te brinda el hombre
Tu escudo fue insuficiente
Tenazas metálicas desgarran tu historia
La bañan con sangre
Tu cuerpo queda abandonado
Mudo testigo de la barbarie.

The Lute

– translation by AMANDA NORA IGONDA HINTZE and the editors

Laments of the lute
Teeming the night
Agonizing sounds mingled
With the murmur of waves
Cast their white gauze
Bandage for your wounds.

For sixty years you sailed, evading
Countless perils
You, vanquishing chelonian
This day your luck has run out

Man renders you undeserved pain
Your shield proves of no avail
Metallic claws tear apart your history
Bathe it in blood
Your body lies abandoned
Silent witness of the savagery.

Memografía

Te conozco tan bien
que cuando te veo pensando
y extendiendo tus alas anaranjadas coronadas de negro
sé que te llama *Michihuacan*.

Que es allá donde quieres estar –
con los tuyos. Allá donde
recuerdas el olor del Oyamel. Allá
donde tus alas despiertan con la sonrisa
del sol sobre tu sien. Allá
con todas las mariposas
que pasaron al otro lado
en el bosque de los sueños.

Que es allá donde quieres tomar
de los lagos con la trucha
esperando tu regreso. Allá
donde ves tu cara reflejada, vistiendo
de colores el alrededor de tus días,
y tu presencia alegra, haciendo reír
a los árboles hasta la raíz
con el cosquilleo
de tus pies.

Déjate volar, y busca aquel lugar
donde regocijas en los vientos –
húmedos y frescos,
donde el cielo se llena de aleteos.

Michihuacan: nombre en náhuatl para el estado de
Michoacán, México.

Memography

– translation by the author

I know you so well
that when I see you thinking
and extending your orange wings crowned with black,
I know Michihuacan is calling.

That it is there where you want to be –
with your own. Over there
where you remember the smell of Sacred Fir. Over there,
where your wings awaken to the sun's smile
on your temple. Over there
with all the butterflies
that moved to the other side
to the forest of dreams.

That it is there where you want to drink
from lakes with trout
awaiting your return. Over there,
where you see your face reflected, dressing
the surrounding days with color,
and your presence cheers, making the trees
laugh to the root
with the tickling
of your feet.

Let yourself flutter, and look for that place
where you rejoice in the winds –
humid and fresh,
where the sky fills with fluttering wings.

> *Michihuacan* is the Náhuatl name for the state of Michoacán, Mexico.

JOSÉ VÁZQUEZ SÁNDEZ

De Tomates

Tomate a la deriva
Flotas subes y bajas en la mar
Te veo solo, verde, mojado
y
pienso French fries.

Tu caja hecha trizas,
nula risa en la mar.
Artera y salada inmersión
Flotas, bajas y subes en la mar
y
Apetezco una sopa Knorr.

Flotas en la mar, subes, bajas.
Más
Son más.
Frutti di mare no sos. . .

Sonido de alerta en la embarcación,
Alarmas, sirenas, mujeres y niños.
¿Tendremos el mismo destino?
Subir, bajar, flotar en la mar

No. Las siete son
A trabajar

Tomatoes

– translation by the author and the editors

Tomato adrift
Floating up and down in the sea
I see you alone green wet
and
I crave French fries

Your crate shred to pieces
no one laughs at the sight
Artful and salty immersion
you float at sea down and up again
Oh!
How I hunger for a Campbell's soup

Floating in the sea, you go up, you go down
more
there are more of you
Frutti di mare you're not

Warning sounds in our ship
sirens, alarms all around
women and children first. . .
Does the same destiny await us all?
To go up, down, float adrift on the sea

No, it's 7 a.m.
it's up to work we go!

DAIMARY MORENO

Metáforas De Un Cuerpo En Movimiento # 2: La Dialéctica Del Cuerpo.

Más allá del hombro el codo,
más allá del codo la muñeca,
más allá del dedo la uña.

Del hombro al codo
del codo a la muñeca
de la muñeca al dedo
del dedo a la uña.

Voy anidando en un meñique que
deviene anular de medio índice
ardiendo de pulgar.

Y recorro de la pelvis al cráneo
del cráneo al centro
del centro a la pelvis
y de la pelvis al cosmos.

La redondez de un culo circular
gira
se contracciona. . .

Metaphors Of A Body In Movement # 2: The Dialectic Of The Body.

– translation by the author

Beyond the shoulder the elbow
beyond the elbow the wrist
beyond the finger the nail.

From shoulder to elbow
from elbow to wrist
from wrist to finger
from finger to nail.

I'm nesting in a pinky that
becomes ring finger of middle index finger
burning of thumb.

And I go from the pelvis to the skull
from the skull to the center
from the center to the pelvis
and from the pelvis to the cosmos.

The roundness of a circular ass
turns
it contracts. . .

OLGA GARCÍA

Los Migrantes

– para DANIEL WATMAN

aquí ellos
calendario calavera calostro caligrafía calistenia
cal y
más cal

aquí
canto y estómago los pies morenos

aquí
a los cuatro vientos libélulas de suásticas
a los cuatro vientos el crepúsculo salpica dientes
a los cuatro vientos sudor cenizas y plomo

a los cuatro vientos como pájaros-horóscopo

en cada piedra cactus de pulmones rotos
en cada piedra el luto jaguar de la Vía Láctea.

circuncidados por un cielo de púas ellos
el escalofrío a contraluz.

Leído frente al muro divisorio entre San Diego y Tijuana
en el Border State Park en San Ysidro mientras los niños
volaban papalotes en ambos lados de la frontera.

The Migrants

– for DANIEL WATMAN

– translation by JULIE BROSSY *and* MEGAN WEBSTER

here they are
a calendar a skull colostrum calligraphy calisthenics
lime and
more lime

here
brown feet, chant and hunger

here
to the four winds, dart dragonflies of swastikas
to the four winds, dusk splatters teeth
to the four winds sweat, ashes and lead

to the four winds, like birds of the zodiac

in each stone, a cactus of broken lungs
in each stone the mourning jaguar of the Milky Way

circumcised by a barbed wire sky they are
a shudder against the light

> Read aloud at the dividing wall between San Diego and
> Tijuana in Border Field State Park, San Ysidro, as children
> flew kites on both sides.

Te Pintaron Con Pinceles Finos

Te pintaron
con pinceles finos
con atención particular
los ojos,
las cejas
y las sutiles sombras
por tu nariz.

Para tus labios
cambió el artista
de pincel:
a un rojo agobiante
que tenaz vive
en mi imaginación

Para el brillo de tus ojos
te salpicó con agua bendita
desde las yemas de sus dedos.

Antes de pulirte para el mundo,
colocó sus dos más bellas brochas
como una,
y otra,
capa de tu pelo.

Y por eso,
por eso,
luces como una obra de arte
día tras día.

They Painted You with Fine Brushes

– translation by SONIA GUTIÉRREZ

They painted you
with fine brushes
paying close attention
the eyes,
the eyebrows
and the subtle shades
of your nose.

For your lips,
the artist changed
the brush:
to a stifling red
that tenacious, lives
in my imagination

For the luster of your eyes,
he sprinkled you with holy water
from the edge of his fingertips.

Before polishing you for the world,
he placed two of his most beautiful brushes
as one
and then another
layer of hair.

And for this reason,
this reason,
you look like a work of art
day after day.

Espícula

Sólo soy un erizo, me dijiste cuando levanté en el aire
 tu frágil osamenta,
tu cóncavo estupor sin memoria suspendido en ajeno trote.
Ya no supe de mí:
una a una hice mías tus púas,
vibró suculenta mi melena y me convertí en Medusa.

Thorny One

– translation by the author and EDITH JONSSON-DEVILLERS

I'm just a sea urchin, you said when I lifted your
 brittle bony skeleton into the air,
your oblivious concave daze suspended in an alien ride.
Then I don't know what happened to me:
one by one your quills became mine,
my luscious mane quivered and I became Medusa.

Lauri García Dueñas

La tía

me sequé el vientre dos veces
el olor de mi sexo es fuerte
cometo cacofonías
alucino que cometas radioactivos caen sobre mi calle y nos
matan a todos
los cangrejos de mar pusieron sus huevos en mis ojos

lloro langostas

¿irá la iridiscencia a morir en mansedumbre?
dionisíaca resiste, firme en la ruptura
mis dientes brillan
pienso en mosquitos zumbando y no duermo
(el calor es una masa ardiente en el trópico)
descalza desando el dictado medieval
el canto prehispánico roído en alusiones épicas
colecciono fósiles de antepasados y visto mis santos para salir
a pasear

tenazas metálicas

creerán que soy un artificio fácil y cómodo
pero mi piel no es un reptil si no más bien
un cuerpo atravesado por mandamientos desobedecidos

The Aunt

– translation by CARLOS MIRANDA, MARA PASTOR *and the editors*

I dried my womb twice
my vulval fragrance is strong
I commit cacophonies
I hallucinate about radioactive comets falling on my street killing
all of us
the sea crabs have laid their eggs in my eyes

I cry lobsters

will the iridescence die in benign passiveness?
Dionysian resistance, firm in its breakup
my teeth shine
I think about mosquitoes buzzing, can't sleep
(the heat is an ardent mass in the tropics)
barefoot I break with the medieval dictate
the Pre-Hispanic chant gnawed by epic allusions
I collect fossils from my ancestors, dress up my saints to go for
a stroll

metallic pliers

they'll think that I'm a comfortable and easy device
but my skin is not reptilian rather
a body perforated by disobeyed commandments

> *dress up my saints*: an expression alluding to a woman who
> has remained a spinster.

ALICIA SALINAS

Cuando La Luz De La Calle

Cuando la luz de la calle lo permite
los niños juegan con la muerte
quien pasea
merodea las esquinas
y observa la fragilidad
de sus cuerpos
con sonrisa socarrona

Cuando la oscuridad ha caído sobre la calle húmeda
los niños
los mismos
guardan los brazos bajo las piernas
las cabezas en los cuellos
y sueñan
que se deslizan por el tobogán del cielo
Tanto suben y bajan
que despiertan
en medio de la calle
tiritando de frío

When The Street-Light

– translation by EDITH JONSSON-DEVILLERS

When the street-light permits
children play with Death
who walks around
wanders about street corners
watching the frailty of their bodies
with a sneering smile

When darkness has fallen over the wet street
children
the same ones
put their arms under their legs
their heads down their necks
and dream
they run down heaven's slide
They climb up and down so much
that they wake up
in the middle of the street
shivering with cold

<div align="right">QUETZALLI PÉREZ OCAMPO</div>

UV

Traspasas mi piel
con tu imperceptible luz,
tu caricia quema
sigo aquí
bajo el sol
inmóvil abierta adicta
a tu dañina invisible
ultravioleta presencia.

UV

<div align="right">*– translation by the author*</div>

You go through my skin
with your subtle light,
your caress burns
I continue here
under the sun
still open addicted
to your harmful invisible
ultraviolet presence.

Tú

Las noticias de la guerra,
el frío excesivo,
los discursos de los nuevos demócratas,
las malas canciones,
las noches sin luna,
el tráfico de mediodía,
las muertes imprevistas
inadmisibles, injustas,
la ausencia de amigos
y de buenos libros,
andar sin dinero,
nuestra patria tan pobre,
nuestra tierra tan triste,
la desesperanza globalizada,
el cinismo televisado,
las invasiones arteras,
la historia oficial,
los animales irremediablemente perdidos,
la decapitación de los árboles,
el exceso de nostalgia,
el maltrato,
la indolencia,
la malquerencia,
son cosas que puedo soportar,
porque es el mundo donde estás tú.

You

– translation by ALFONSO GARCÍA CORTÉS *and the editors*

War news
excessive cold
speeches of the new democrats
bad songs
moonless nights
midday traffic
unforeseen deaths
inadmissible, unfair,
the absence of friends
and good books,
going about without money,
our so poor homeland,
our so sad land,
the globalized despair,
televised cynicism,
cunning invasions,
official history
animals irremediably lost
the beheading of the trees,
nostalgia excess,
mistreatment,
indolence,
ill will,
are things that I can bear
because it's the world where you are.

Aída Mendez

Robando Luz Al Sol
– para el Abuelo Pancho Morales, Alejandro y Lobo

Soberbio y elegante
silencioso el gato
hace la corte a la noche
solitario y mudo
lima su pelaje ausente de color
sobre los muros leprosos de la calle sexta
estridente, la música acompaña sus pisadas de fantasma

La estrella brilla profana
los borrachos de amor salen de las cantinas matándose a besos
las camas de paso unen cuerpos,
brazos,
piernas,
bocas,
corazones
lenguas inflamadas sumidas en la melaza incandescente
 del amar
los desencantos vendrán indecisos
con la luz insolente que entrara sin precaución por las cortinas.

Robando Luz al Sol por Betsy Pecanins

Stealing Light From The Sun
– for Grandpa Pancho Morales, Alejandro and Lobo
 —translation by Alejandro Rodríguez

Proud and Elegant
silently, the cat
courts the night,
solitary and mute
it files its colorless fur
on the leprous walls of Sixth Street
while strident music follows its ghostly steps

177

The star shines profanely
as the love-drunken ones file out of bars kissing each other to
death
temporary beds assemble bodies,
arms,
legs,
mouths
hearts
and swollen tongues swimming in the glowing molasses of love
(amar)
disappointment will come hesitantly
with the impudent light that carelessly filters through
$$\text{the curtains.}$$

Stealing Light from the Sun: a song by BETSY PECANINS

JHONNATAN CURIEL

Muerte Digna

Aunque mis asesinos no quieran
tendré una muerte digna
porque antes me habré dado permiso de morir
y cuando me impongan su crueldad
reiré para mis adentros
pues sin saberlo ellos
estarán cumpliendo mi deseo.

Honorable Death

– translation by GIDI LOZA

Although my murderers don't want it
I will have an honorable death
because I will have already granted myself permission to die
and when they impose all their cruelty upon me
I will be laughing inside
because without knowing it
they will be fulfilling my wish.

178

Ofrenda
– para mi madre

cuando no llueve
y el día se ha secado un poco
sales a cultivar el jardín
a tus ochenta y nueve años
te alegra sentir la tierra húmeda
podar las ramas
quitar hierbas

como la primavera de California
das más de lo que esperas
resplandeces con tus sorpresas de niña

entras con un ramillete para mí
jacintos
alcatraces
rosas

un bromelio respira el aire de cocina azul
me sirves té con leche
escuchas mis historias
cuentas las tuyas
con el júbilo de los lirios morados
que se multiplican por gusto

mi refugio
te miro cambiar con las estaciones

junto al fuego del salón
descansas cuando se pone el sol
recuerdas otros jardines
sueñas con colores nuevos
solitarias
margaritas
geranios por plantar

Offering

– for my mother

– translation by the author

when it doesn't rain
and the day has dried a little
you go out to work in the garden
at eighty nine
you like to feel the wet earth
prune branches
do some weeding

like spring in California
you give more than you expect
shine with little-girl surprises

you come inside
with a bouquet for me
hyacinths
calla lilies
roses

a bromeliad breathes blue kitchen air
you serve me milk tea
listen to my stories
tell me yours
with the joy of purple irises
that multiply from happiness

my refuge
I watch you change with the seasons

beside the fire in the living room
you rest when the sun goes down
remember other gardens
dream new colors
pansies
daisies
geraniums to plant

Teresa González-Lee

El árbol del amor imperecedero, *Dracaena draco*

Anclado a su poder ancestral
se yergue el árbol Dragón "Dracaena Draco"
en arrecifes montañosos de piedras volcánicas
con troncos entrelazados
hojas enhiestas como espadas hojas fuertes como garfios
liadas por mil ataduras vasculares
donde circula una roja savia
la sangre poderosa y única de Dragón.

En aquel hilvanar de volcanes sumergidos
del Archipiélago Canario esconde el árbol Dragón
su atracción misteriosa magnética de acero
entre barrancos inaccesibles
huyendo de las creencias míticas folclóricas
de canarios aboriginales y de españoles

Allende el Atlántico enclaustradas dentro de los muros
del Jardín Botánico de San Diego trabajan
manos laboriosas manos generosas
hospedando una flora traída de lejos global
mientras brazos fuertes brazos amables ciñen la cintura
apretada de árboles exiliados privados del habitat del Paraíso
y siembran con semillas inmigrantes un futuro en diversidad.

Árbol Dragón es hora de desplegar tu poder ancestral
aquella mágica fórmula viviente de milenarios años
presente en el color anaranjado de tu savia
pulsante en el corazón carmesí de tu fruta maravillosa.
Permítenos brindar hagamos un pacto solemne al
Amor que no Muere
degustando de tu savia apasionada
lamiendo sorbiendo dentro de un beso tu imperecedero
filtro de amor.

The Tree of Imperishable Love: *Dracaena draco*

– translation by the author

Pledged to ancestral powers of millenary years
the Dragon Tree "Dracaena draco" stands tall
on mountainous cliffs of volcanic stones
with intertwined trunks
sword shaped claw-like leaves
tied by thousands of vascular binds
where a red sap circulates
in the unique Dragon's Blood.

Along a thread of submerged volcanoes
In the Archipelago of the Canary Islands
the Dragon Tree becomes invisible to the eyes
of natives Canarians and their mythic beliefs.

Beyond the Atlantic within the walls of
 the San Diego Botanic Garden
laborious generous hands work to host
 a worldwide flora that was rescued the world over
while strong arms striving for reforestation
sow immigrant seeds for a future of biodiversity
creating in this kind land a refuge for exiled trees
deprived of their habitat, their Paradise.

Dragon Tree it is time to display your ancestral powers
present In the orange red color of your sap
pulsating in the crimson heart of your enchanting fruit
allow us to offer you a toast let's make a solemn covenant
 to Undying Love
let us taste your passionate sap by sipping licking into a kiss
your imperishable love potion.

Proyeccionismo

Buscamos y encontraremos a nuestros adoradores.
A los adoradores ciegos de nuestros ojos deslavados,
de las cicatrices queloides, de nuestras peculiaridades salvajes.
Encontraremos a los adoradores de nuestra imperfección.
A los profetas de nuestras debilidades.
Nos rodearemos de devotos de nuestras obsesiones.
Existirán coros que entonen nuestras ideas hilarantes.
Los creyentes morderán nuestro cuerpo y beberán la sangre
que derramemos durante nuestros días.
Y nuestros eternizadores pronunciarán el nombre.
Exijimos nuestra crucifixión amorosa,
 nuestra pasión polvorienta,
ordenamos se nos entierre bajo una enorme roca gris.
Pedimos nos nieguen, juren en vano nuestro nombre,
rogamos porque desdeñen la vida por una diatriba preciosa.
Que se derrame nuestra sangre sobre los incontables
 ojos abiertos,
sobre las numerosas bocas, que se derrame
sobre los pocos cráneos horadados.
Que nos resuciten con sus gritos, con su negación a la naturaleza,
que levanten nuestros cuerpos hinchados por sus lágrimas calizas.
Que nos resuciten cada fin de mundo bajo su lengua.
Y seremos sus adoradores,
adoradores de sus ojos deslavados, de sus cicatrices queloides,
de sus peculiaridades salvajes.

Projectionism

– translation by MAVY ROBLES-CASTILLO *and the editors*

We seek and will find our worshipers.
Blind worshipers of our faded eyes,
keloid scars, our wild peculiarities.
We'll find the worshipers of our imperfection.
The prophets of our weaknesses.
We'll surround ourselves with devotees of our obsessions.
There'll be choirs singing our hilarious ideas.
The believers will bite our bodies and drink the blood
we shed during our life.
And our immortalizers will pronounce the name.
We demand a loving crucifixion, our dusty passion.
We demand to be buried under a huge gray rock.
And ask them to deny us, take our name in vain.
To reveal why they scorn life for a precious diatribe;
Let our blood spill over countless open eyes,
over numerous mouths, spill
over the few pierced skulls.
Let them resuscitate us with their yelling,
 their denial of nature;
lift our bodies swollen with limestone tears.
Let them resuscitate us under their tongues at the end
 of each world,
and we will be their worshipers.
Worshipers of their faded eyes, of their keloid scars,
of their wild peculiarities.

RosARIO OROZCO

Con Cariño Para Bety

¿Qué te puedo decir?
Si ya no sé qué decir,
de hecho he aprendido a callar,
pero no tu asesinato no,
no quiero ya herir ni con palabras
mientras ellos destrozan con balas
¿Para qué decir?
¿Para qué hacer?
¿Acaso porque creemos que se puede lo que no se puede?
¿Acaso nuestros sueños son su tormento?
Dos balas

Sueños rotos en masacre
Dos niñas que padecerán tu ausencia
un pueblo (inmenso) que te llora
sangre. . . muerte, una mujer más. . .
Impunidad, como signo de modernidad.
Mientras la justicia, sigue huyendo
y nosotros. . . nosotros sin conocerla.

> Dedicado a BETY CARIÑO, asesinada en la sierra de San
> Juan Copala el 27 de abril de 2010, cuando iba en una
> caravana para llevar alimentos y medicinas a la comunidad
> autónoma mencionada.

With Love For Betty

– translation by the author and the editors

What can I say
if I don't know what to say?
In fact, I've learned to be quiet
but your murder no
I don't want to hurt, not even with words
while they destroy with bullets
Why speak?
Why act?
Perhaps because we believe we can do what cannot be done
Perhaps our dreams are their torment
Two bullets

Dreams shattered by slaughter
Two girls who will suffer from your absence
Huge crowds mourning you
Blood. . . death, one woman more
Impunity as a sign of modernity
While justice continues to flee
And we. . . who did not know her

Dedicated to BETTY CARIÑO, killed in the Sierra de San Juan Copala on April 27, 2010, while bringing food and medicines to the San Juan Copala community.

BIBIANA PADILLA MALTOS

Y Porque La Noche Es Callada

Y porque la noche es callada
y las miradas largas
se languidecen los espíritus
las bocas cerradas

Y porque el día es alivio
y los vientos cortos
se evaporan las esencias
los ojos abiertos

Y porque las preguntas son raras
las respuestas no existen

And Because The Night Is Hushed

– translation by the author and the editors

And because the night is hushed
and the looks insistent
spirits flag
with mouths closed

And because the day is alleviation
and the winds short
essences evaporate
with eyes open

And because questions are rare
answers are non-existent

Con El Sol Por Dentro

Tras el antifaz sereno
albergas el huracán
de la zozobra

Llegas
hombre de viento tímida sonrisa
avivas el fuego
y te marchas

Regresas ráfaga violenta
ojo de huracán oculto en el silencio

Vuelves con la quietud en la entraña
rompes la mudez

Espectadora del futuro de tus sueños
temerosa e iracunda permanezco

la fluidez de tu andar constante
quiere encender el fuego

Permanecer
 en aparente serenidad
refugiada
 tras la máscara del desamor
protegida – es mejor –

Te vuelves viento en proa

Sin distinguir
 lo que el corazón alberga
me vuelvo espectadora

Para no sentir
ando con el escudo
incolora
desabrida
 sin aroma
insensible a tus constantes
lla-ma-das lla-ma-ra-das

Hasta ceder
 al miedo que acecha
y reconocer que habitas
 en mí

Ya ves
el silencio
no siempre es el mejor consejero
abre distancias
por eso
llevo el sol por dentro.

With The Sun Inside

– translation by ALFONSO GARCÍA CORTÉS *and the editors*

Behind your serene mask
you harbor a hurricane
of anxiety

You arrive
wind man shy smile
stoke the fire
and leave

You return violent gust
eye of the storm hidden in silence

You come back calm inside
break the silence

Spectator of how your dreams will enfold
fearful and angered I remain

your constant coming and going
 fans the embers

To remain
 in apparent serenity
sheltered
 behind a mask of indifference
protected – is best –

You become wind on the prow

Unable to perceive
what the heart holds
I become a spectator

To not feel
I live behind a shield
pale
insipid
without scent
unresponsive to your constant
c-a-l-l-s f-l-a-r-e-s

Until I yield
to a lurking fear
and know that you live
within me

You see silence
often not the best counsellor
opens distances
which is why
 I carry the Sun inside

El amor es seda

La luna cobriza
ilumina mi ombligo
mientras el escarabajo
que lo habita
vuela hacia la claridad
del deseo

como ola me llega
el crepitar de las estrellas
mi vientre tiembla
deshabitado
me acompaña tu ausencia

escucho tu voz a través
de la espalda marmórea
tu cabello platino
se disuelve en mis labios

importúname con caricias
de sombras palabras
la corteza de tu mirada
tiende puentes a mi alma

hombre en llamas
recíbeme con tus ansias seminales
y exhala sobre mis muslos
El amor es seda
que pende de un hilo.

Love is silk

– translation by ALFONSO GARCÍA CORTÉS *and the editors*

A copper moon
lights up my navel
as the beetle
that inhabits it
flies to my clear
desire

the crackle of stars
comes to me as a wave
my womb trembles
uninhabited
your absence keeps me company

I listen to your voice
through the marble-like back
your platinum hair
melts in my lips

importune me with caresses
of shadowy words
the crust of your gaze
builds bridges to my soul

man in flames
receive me with your seminal desire
and exhale on my thighs
Love is silk
hanging by a thread.

Civilizada. . .

Cuando vine para hacerme de mundo,
la ciudad había desaparecido, la de mis sueños. . .

En su lugar había semáforos, bocinas, pies con prisa
y en el aire espeso de la noche, múltiples manos sin destino
 inventaban flores azules

El musgo indiferente crecía en todas las esquinas
junto al polvoroso crepúsculo que caía
 luciendo destellos de sueños añicados. . .

"La ciudad es bella" me habían dicho, cuando de niña
antes de la primera letra viajaba en un instante
hacia remotos lugares a mirarme en el extraño espejo
 de una presentida juventud. . .

Vine entonces y busqué, esperanzadamente,
un jardín donde el agua cantara, los pájaros hablaran
 y la lluvia fuera lluvia de oro. . .

Vine de la montaña, de un pueblito minero, diminuto,
donde la nevada de diciembre le ayuda a Dios
a pulir los espejos de la noche, mientras todo lo demás
duerme acurrucado en las pálidas filas de casitas
 empapadas del azul del frío de invierno. . .

Yo sólo conocía unas cuantas canciones pero. . .
sus lúdicas frases cayeron después en oídos herrumbrosos, ajenos,
y tuve que acostumbrarme a los falsos modales de la nada
 en este otro frío apenas descubierto. . .
Decidí entonces volver a mi montaña, a las cuatro estaciones
 donde el verde apenas comenzaría
 donde los cerros, donde la espiga, donde la leña. . .
De esta civilizada vida hay sin embargo, un saldo: ¡tanta vida, tantos siglos-
semanas, tanto ser! Ser que he decidido poner
 ¡al servicio mayor de los recuerdos. . .!

Civilized. . .

– translation by EDITH JONSSON-DEVILLERS

When I came to meet the world
the city had disappeared, the city of my dreams. . .

In its stead were traffic lights, horns, hurrying feet
and in the thick night air, multiple hands without destination
 were inventing blue flowers

Indifferent moss grew on every street corner
next to the dusty twilight falling
 flaunting sparkles of shattered dreams. .
 .

"The city is beautiful" I had been told, when as a little girl
even before the first letter I traveled in a moment
to distant places to look at myself in the strange mirror
 of youth already imagined. . .

So I came and hopeful sought
a garden where water would gurgle, where birds would speak
 where rain would fall in golden shafts. .
 .

I came from the mountain, from a tiny mining village,
where the snowfall in December helps God
polish mirrors of night, while everything else
is sleeping curled up in the pale rows of little houses
 drenched in the cold winter blue. . .

I only knew a few songs but. . .
their playful phrases fell afterwards on rusty ears, alien ears,
and I had to get used to the false demeanor of nothingness
 in that other cold barely discovered. . .
I decided then to return to my mountain, to the four seasons
 where green would soon spring up
 where the hills are, and the ears of wheat, and the firewood. . .
Yet something is left from this civilized life: so much life, so many century-
long weeks, so much being! A being that I've decided to put mostly
 at the disposal of memories. . .!

MARVIN DURÁN

Ligero

Ligera es la sombra de mi barba
ligero es el silencio de tus besos
ligeros son los pasos redentores
liviano como hojas de cerezo
Ligeros los momentos olvidados
por memorias ligeras de recuerdos
ligero el pasajero dromedario
perdido entre las dunas de tus miedos
Ligero de pensar resulta odioso
ligero sin café, sin desacuerdos
ligero me presento ante tu sombra
guardando mi calor para otro tiempo

Fragile

– translation by PATRICK COX *and the editors*

Fragile is the shadow of my beard
the silence of your kisses
the steps towards atonement
fragile the cherry leaves
as forgotten moments
fragile is the memory of my remembrance
a laden camel
lost in the dunes of your fears
wayward and hateful
fragile I am without coffee, without disagreement
fragile I stand before your shadow
keeping my warmth for a nicer day

La Noche De La Luz

Esta oscuridad es tan nuestra
como la luz que la viola sin cesar.
Estos ojos de fuego y penumbra
serán testigos del alarido de hombres y mujeres
que claman amor, paz y fe verdadera

Tregua a los discursos acaecidos en el poder,
tregua hermanas y hermanos.
Se viene la noche de la luz
como una profecía de amor infinito.

El pecado será llamado error y
el error nunca más será llamado pecado.
Ésta es la oscuridad de la belleza.
El pulso del cosmos en nuestras venas.
El río que se trifurca en nuestros pechos desde el centro
hacia abajo
hacia los costados.

Ésta es la oscuridad del umbral
entonando eterno equilibrio y
nuestras voces al unísono
ofrendarán con su canto todas las flores de la tierra al universo
para que se teja una manta de caricia humana
que le acompañen en su eterno viaje.

The Night Of Light

– translation by JULIE BROSSY *and* MEGAN WEBSTER

This darkness is as much our own
as the light that rapes it without ceasing.
These eyes of fire and shadow
will witness the howl of men and women
demanding love, peace and true faith

Truce for the speeches issuing from the powerful.
Truce sisters and brothers.
The night of light will come
like a prophecy of infinite love

sin will be called error
and error will never again be called sin
this is the dark side of beauty
the pulse of the cosmos in our veins
the river that forks
from the center of our breasts

This is the darkness of the threshold
singing eternal equilibrium
and our voices, in unison
will sing an offering to the universe of all the earth's flowers
to weave a mantle of human caresses
that will accompany it on its eternal journey.

Guerra Fría De Silencio

Ser poeta
en circunstancias como ésta
resulta peligroso

[somos vulnerables]

andar la vida
con palabras de amor
en la punta de la lengua
—desbordadas, a punto de
verterse. . .

[somos una bomba de tiempo]

las noches son un campo minado
el próximo paso
puede volarnos en mil pedazos las metáforas
y entre lágrimas
se nos escurren las imágenes

[somos paranoicos espías]

acechamos la piel que pueda servirnos
de blanco
soñamos con lanzar palabras
sospechamos de toda
posibilidad

[somos, ciertamente, peligrosos]

Cold War Of Silence

– translation by ALFONSO GARCÍA CORTÉS *and the editors*

To be a poet
in circumstances such as these
turns out to be dangerous

[we are vulnerable]

going about life
with words of love
on the tip of the tongue
— overflowing, about to
spill. . .

[we are a time bomb]

The nights are a minefield
the next step
could blow up the metaphors
into a thousand pieces
and among tears
images would slip away from us

[we are paranoid spies]

We stalk the skin that could serve us
as a target
we dream of hurling words
we suspect all possibilities

[we are certainly dangerous]

ALFONSO GARCÍA CORTÉS

Algo Viene En El Aire

No eres tú
Aunque también trasciendes la distancia
Y
Como el polvo
Hallas hogar entre las hojas de mis libros
Y como el polvo
Te deposita el viento en los rincones
En los goznes
En el secreto aliento de la noche

Algo, les digo, viene en el aire:
Un tenue olor a muerte
El rumor del oleaje

La desgranada voz de las pirámides. . .

Something Is Blowing In The Wind

– translation by the author and the editors

It is not you
Although you too transcend the distance
And
Like dust
You find a home between the leaves of my books
And like dust
The wind deposits you in the corners
In the hinges
In the secret breath of night

Something, I swear, is blowing in the wind
A subtle smell of death
The murmur of waves

The crumbling voice of the pyramids. . .

ENCORE

Consulting the Akashic Record

– for Steve Kowit, after running me through an engram process

I dive deep down
neural pathways, down
cultural, cross-generational
obscure tracks, deep
in earth memory
and re-call a scene
of one who was me
then in an ocean,
drowning,
an ancient ship in the distance
sinking, me sinking then shooting
straight up. . .
nothing else, just
this fragment from the record
of one at the moment
of his death,
no emotion, no pain,
just pictures.
Memory and invention,
are they really separate?

Modern Poetry

Only the blind would caress
 these decayed leaves.

Dark of the Moon

Mercury in Retrograde. . .

Shall we face the dark of the moon tonight,
 invisible as it is now, unable to mirror the sun
 for this phase – a bean pot of days –
 the only time quicksilver can be seen
 against the sky. Mercury doing his thing,

His wings blind us,
 yet reflect everything,
 warts and all.

Only the Sisters can see
 behind his mirror,
 their skirts trailing night & hard to believe,
 like walking clouds

On that hidden side of Luna,
 Mercury's mirror
 her poison herbs will root & bloom,
 & we'll cower, we'll quake. we'll rage,
 we'll trample

yet, when light returns, only those
who have been there,
those whose mouths have opened,
whose hearts have tasted
& bled & wept,
will heal.

HARRY GRISWOLD

Rings of Lubricous Time

The snake I stuffed still pooping into my pants pocket,
grasshoppers that spit before pushing from my finger
leaving tobacco residue and prickly feelings,

dandelion seeds we scrambled and blew to the breeze
in days of writing down, for no reason, license numbers
from all the cars on the street, smells of sharpened

pencils, new books, hopelessly black kerosene-ball
lanterns workmen would light where they dug a hole,
maple trees in their rites, puffing up buds till they

exploded in golden showers that covered the streets
soundlessly, green leaves turned at last to yellow or red
then brown, rustled and raked along the ground until

burning nights tasted rich as beef gravy on potatoes,
the swish of fly-bothered horses hauling beer trucks,
the kegs men would bounce and pound down between

creaky doors at the tavern up the street, kids still hard
at play when windows yellowed to steady calls of light,
then morning risen again on wind, on factory whistles,

quarter-hour bells, on the rhymed cars of pulled trains
that sang long in their rounds, in their rounds.

MEGAN WEBSTER

A Day in the Life of a Cow

No one gripes among the bovine
tribe. Grateful each for tufts
of green to cushion weary soles,

they chew on cud for hours,
nothing else in mind. Come sun
down, udders taut as balloons,

they're rounded up by dogs,
who woof them out of pasture
to milking sheds, where

machines suck them clean
of milk, their day's long moil.
Prone in straw-lined stalls,

dewlaps napping in their laps
they ruminate, dream
of green (or red) or moist

fresh cud – or jumping over
the moon – with never a moo
of complaint.

qubit

– a unit of quantum information, stored in a two-state quantum system.

I've had it with dross
give me raw stark thoughts
direct images
fame sex & money
just kid stuff really
compared to big league
mind-blowing concepts

like quantum entanglement
you can separate a thing
no matter how far away
parts will stay in constant sync
like a mother and children
father & his kid's mother
or love cut off in full bloom

quite a mystery
called spooky science
drove Einstein crazy
the feeling deep down
lingering softly
in your heart of hearts
that true love lives on

POLINA BARSKOVA

Summer Physiological Essay: Wanderers

Was noticed by me –
A madman who destroys Berkeley's snails;
On his head, a black towel,
In his hands, an enormous trident.
He looks for snails in the gardens, by the fences.
He catches them at each gate, jumps on their bodies.
On the earth, their remains: shells, liquid pieces.

– You asked that I write about our life – I write about our life.
Strangely it often becomes so. . .elementary. . .
In our village where small animals live slowly
And humans jump on them.
Our village is covered with unbearably green ropes.
And with a superior stare
My two-year-old daughter
Observes her country through heat

And moisture. She rides in her baby carriage
Under the tedious leadership of her grandmother.
And they need no one. As if they were alone on earth.
Two beautiful animals, woven into the landscape
Of each other. They stand quietly over a snail
Which survived the holocaust of the neighbor's foot.

Here they are still, over a sign
Like a hieroglyph that arrived to them.
Nona bends down. Frosya with
A lively little leg beats her other lively leg, hanging
Over the pebbles in the driveway.
What do they see there, tell me, what do they hear?

And, where do they walk together
Each morning ahead of all those who drive and cry and
breathe and
Manufacture all earth's news.

– *translated by* KATHRYN FARRIS *and* ILYA KAMINSKY

KATE HARDING

Why We Fear The Hassidim

– after ROBIN BECKER

The men with their little side curls, long coats,
black hats, bent in discussions more important
than anything we have to say.

The women with their stiff, perfect wigs,
their below the knee length skirts,
and expensive silk blouses designed to cover
their dangerous, lust-inducing clavicles.

The women coo in their kitchens, a covey of them
in their dove colors, kneading dough for challah,
our great grandmothers' recipe the rest of us
have long forgotten.

As if suffragettes never chained themselves
to lampposts, or Gloria, that ex-Playboy bunny,
Steinem, with her tinted glasses, never waved
a placard for the ERA

the women whisper and giggle in the steam
of stews and soups, while their rosy-cheeked rabbi
husbands gather for *real* work in their studies.

And why do the Hassidim insist that their Sabbaths
are on Saturdays? While we dart from Petco to
Costco for cat litter and coffee or just laze at home

recklessly flicking light switches on and off,
the Hassidim gather in their German cars
in the parking lot of the Chabad. BMWs! Mercedes!
As if the Holocaust never happened, or they forgive

Hitler and Goering. The men in black, the dove
women clump together at the corner of Governor
and Radcliff. They must believe University City

is some crazy new promise land and the Baptist Church
next door and the Palestinians at the Mobil Station
want them in their neighborhood. One boy with ringlets

stalls at the Temple door. His eyes slide sideways,
he stares at kids his age in baseball caps across the street
at the park. The Hassidim's prayer *Shabbot Shalom*

wafts over the busy boulevard, over busses braking
at the light on Genesee, over the slap of bats on balls,
over dry-throated shouts of Little League parents,

over the hum of Marine planes practicing war games.
Shalom. Shalom.

Charmed against my will

White butterflies dance in the air
over the garden in the August sun
The air is a drum the sun beats
almost deafening. Bright
as broken glass.

Their dance is seductive, of
course. They will mate soon
and lay eggs on the cabbage
plants below to hatch hungry
green gnawers.

I am a gardener. I will squash
their offspring. Yet the white
dance enters my eyes
like a song and I dance
with them, rising.

The Depression Lifts

so I rise as the sun rises,
walk into the kitchen,
my hand touches my silver kettle,
I jump back.

Sunlight through a maple tree
paints shadows on yellow walls –

shadows moving
on every cupboard,
each wooden spoon,
china cups, yes –
even the silver kettle,
even my own hand.

So this is morning
in my kitchen,

as if you're standing in a beehive.
Hundreds of fluttering wings.

There is nothing prettier.
The room trembles,
I blush.

DHR FISHMAN

detention Buddha

– for REJ

meditate on nothing to stay out of the nothing
to deal with the nothing
Don't hate the fat man who put you here
because you called him fat
in front of the kindergartners

Be bigger than that; float
on your lotus flower
whole in your wisdom

Breathe
in
fresh Spring air
flowing through the open window
transmuting to strength in upright body
vital limbs,
the current that can't be stopped
warm from the sunny day you're not out in
but too with its early-year chill threading through it;
air is not detained

anger is attachment
the teacher-need to follow rules is attachment
the Buddha nature knows
there is no detention

In The Mirror

— a reply to ZBIGNIEW HERBERT's **Why the Classics**

In the mirror in a cheap motel
I peeked shyly, afraid we'd look
ugly, two heaving animals.
Instead I saw our bodies glowed,

rocking and cradling
in the room's drowsy dusk,
our skins' faint light
lacing our outline,

our curves and hollows
fused against the hum
of the freeway that divides our lives.
I used to think sex had to do with

power. In the mirror I saw
two creatures clinging
to each other,
pale and mothlike,

printed on the dark –
while empires fall,
and Thomas Aquinas,
saying his last mass,

catches a glimpse of God –
points to his seventy
volumes in scholastic Latin,
mutters: "So much straw."

BRAD MCMURREY

The Final Cut

Behind us in the picture is the Eiffel Tower.
We climbed to the top laughing,

just before going to Venice,
where beautiful facades sink.

Perhaps with a microscope,
I could see the line between us better,

as my freshly sharpened scissors
slice through the paper.

We were a good pair too,
but there was no infomercial product

to sharpen us back to life
when we dulled.

Wait, what will I do
about that arm on my shoulders,
curved around my neck,

hand over my heart?

JOAN GERSTEIN

Compass to My Son

I imagine the mystical song
of humpback whales
as they traverse the oceans
from Hawaii to Alaska.
They need no roadmap,
nor flocks of geese and cranes
migrating across northern skies.
Salmon leave the sea,
travel thousands of miles
to the place of their birth.
Even the sea turtle finds her way to shore.

Yet I am lost.
My directional gene is marred or missing.
I cannot orient myself to sun or stars.
I do not see navigational cues.
I had no early practice,
not allowed to venture
from my Brooklyn block.

I may have travelled *the road less taken*
and not known it,
so anxious to find my destination.
Earth's gravitational pull has no sway
as I blindly wander about.
I miss mysterious paths
and hidden byways.
Today with written directions,
memories of six times
meeting Daniel at his place of work,
I drive down a wrong street.
I do not orient myself to son or stars.
I fail again.

DIANA GRIGGS

"Keep Thee Only Unto Him, So Long As Ye Both Shall Live"

– from the Book of Common Prayer

Didn't I once enter a Cathedral
to meet you at the end of the aisle
you, waiting for me to be given.
Wasn't that what I always wanted
to leave on your arm
bells pealing from the tower
gold band around my finger
my guarantee for happiness.

When was it that I stood in our flat,
night rain rapping on the windows
damp diapers draped over chair backs
fretful baby in my arms and the weight
of a promise made before God
hanging like a yoke around my neck.

JIHMYE COLLINS

Eyes on the Prize

Eyes on the prize
of a peculiar freedom
the first act required
a ground zero monopoly blueprint

conservatism's motor of advantage,
a presumed subtle default
on the art of compromise

the wisdom of father time retarded,
hannibal fast-forwarded
sporting a new name
predators no risk elephants of steel,
night barking dogs quieted
smell of carnage, imposed lethargy
ghettoizing spirits of people
who know not the demonizer

no fingers to lift unbalanced scales
of lady Justice,
who winks an uncovered eye
always with a westward glance
underscoring the politicians' last words,
for God to bless America
some more

Curry River

The spring storm from the high country
dumps snow and sleet on the valley floor, chasing us inside
to find sanctuary with strangers.

The granite fireplace,
made of stones scattered by a retreating glacier,
has heated the room too warm.
Packs and rain gear stack up in piles.
Wool shirts and socks
create their own steamy microclimates.
Through the window, water drips steadily
from eaves and a dogwood's luminous
blue-yellow petals hold white crystals
like translucent china.

It's a drowsy day, a moment out of time.
The women have broken out the jigsaw puzzles.
One finishes *A History of the West*
with just a single piece missing
among the wagon trains and territorial wars.
Another has tucked herself neatly up to a table,
short gray hair pulled back with a school girl's clip,
face lit with pleasure as she scans the scattered pieces,
glancing from the box top Yosemite Valley,
to the world outside the window.

Hearts Wandering like Li Po

– for YUAN YUAN 2010

I think of you on your travels
with three young men
who speak in German
and the one you love
who speaks with you in English
and touches you at night
I think of the mountains you see together
the sea of faces
the steady music of the rails
like love
carrying you to waterfalls
to streams
through the green forests
of your youth
and I become young again
with your delight
yet my heart remains old
filled with the wanderings of Li Po
and his pots of wine
with only the moon for company
in an autumn of longing
it is anxious to tell you
what you already know
take it grasp it devour this journey
every leaf
 every tear
 every kiss
will never be quite the same again.

Ms. Hilton

One evening in June,
Paris Hilton appears on my
TV screen, seated across from
Larry King. Her eyes are dark
bins of betrayal. Her stream
of yellow hair looks as good
gold nuggets in a Klondike creek.
The hunched-over King strains
towards her fragile body like
a vulture about to nibble on
a new-born chick.
I sip my watery margarita,
eager to know what this
soft-edged jailbird has to give.
She nuzzles her powdered
jaw against an invisible shoulder.
Her eyes look out to me with
neither irony nor regret.
She pouts about the cafeteria
food, the dismal shopping
from a metal cart, the bible
whose verses cannot comfort
or illuminate. She's been to
jail and now she's out.
We've all been there with
her, or so it seems. Quietly,
we wet our lips, finger our
maxed-out credit cards,
flip open our cell phones,
return to life on the streets.

Cabo Virgenes

Dark intruding eyes wander over sand and sea
at sunset a blanket of small stones seashells
scattered bleached bones of birds and big fish
Penguins in white starched shirts
waddle like slap-stick comics
in long lines up and down the desolate beach
on sparkling specks of sunlight
washed ashore by ebbing waves of day

The Patagonian sky
at dusk
a curdled cup of blood
Magnus the wandering Jew
drives our tiny Toyota
like a daring fool
on miles of rutted pot-holed
dirt and gravel roads
leading to La Estancia Monte Dinero
illuminated by a lonesome full moon
in stark relief to dark barren hills
looming behind the ranch house

where we are welcomed by a brunette
in tight jeans and sleeveless sweater
who serves carne asada
and rich red wine
to Spanish speaking blondes
sitting at the banquet table
before the great hearth

Her soft southern smile
warms our chilled bodies
better than burning logs
in the huge fireplace
After *sopa y vino*
we resume our risky ride
on the open road
into wet windswept
Patagonian night

RUTH RICE

The Task

It is warm in Elsie's room,
Lace curtains patterning afternoon sun.
We are in companionate quiet –
Me, Elsie, Collen the caregiver,
And Death, lounges amiably
In the chintz armchair.
We know why we're here today,
Old colleagues and sisters at the wheel –
Coleen cracks her knuckles,
Puts on a tape of hymns to play,
Elsie clasps fast my hands,
Lips moving like leaves
Of an offered wish, while
Death hums a distracted tune,
Biding the moment.
We are a still life of buttered light
Ripening a final afternoon
With the rightness of our being
Together in this room.

KEN SCHEDLER

Old Cat / New Tricks

Don't ask me why, it's crazy
We now let our matron cat roam
For 15 years she's lived indoors
A virtual captive in our home

So now when the day is sunny
She camps out close to the door
Awaiting its first opening
A surfer poised on the shore

With a blubbery bounce to the porch
She finds it loverly to be outside
Runs around for a while in the open
Then seeks out new places to hide

I keep wondering what that's like
As an old dog myself I know
How hard it's been to learn new tricks
But for her nothing new is de trop

JOHN WEBB

The Gift

(memories of Julian, CA & MOZART)

The cold sky folds itself into darkness. . .
fish-scale sun-flakes tremble along the lake.
Your fingers are petal-soft, beloved. . .guiding
shy dreams through wine-dark tomorrows.

LINDA ENGEL AMUNDSON

Wounded

in moon shadow
your sweat streaked face
 is the mask of an artist
an imprint on the shroud of our times
in wait for the AmVet bag

the pain in your music
cracks the piano keys into
notes of exquisite agony
worthy of saints and madmen
rocking naked on a bench at Bedlam

my anvil heart
will not allow
any movement beyond
the reflecting pool
of our early years

when I would reach
to touch your peach fuzz face
and you would reach
to touch my breast
no longer there

Salzburg

Twilight shadows fill the room,
 but I stay seated at the writing desk,
lights off. My
fountain pen runs dry,
 and I merge with the sounds of early evening:
the rasp of the green
grocer's shutter chain,
the dopplered crescendo-decrescendo of a minibus full of
schoolgirls, an iPod leaking one ear-bud of Die Zauberflote . . .
an hour slips by.

off-and-on drizzle
the doves on my windowsill
preen one another

I'm late. In the lift to the lobby, the ticket in my pocket feels
brittle, remote. I follow my
feet through the old center of the city . . .
 down the damp corridors of patience, along the
boulevards of longing and abundance,
 through the night's high colonnaded arias . . . until,
soundlessly, I enter that cathedral of solitary oneness,
in love with the dreaming world
that rolls toward me like a golden ball.

after Mozart
the rhythm of motorbikes
on wet cobblestones.

DANIELA SCHONBERGER

In the Afterlife

Have me admired
in the delicate jasmine
placed behind a girl's ear

or have my finger-dance tasted
in the next orange slice
a boy eats

but Death, do not retire me
into the man-made wooden chair,
nor the woven basket dirty socks and shirts
get tossed in.

I won't be a dead thing.

Rather, have me channeled into:
a duckling fluffing wings
while wading through streams.

Flush me out to a safe haven,
these waters, this air,
all of it – mine and yours.

CHRIS VANNOY

Mary Magdeline

She was just passing through
on her way to Wisconsin
on her way to Detroit

She would be there
for only one week
her bags were packed
with many circumstances
the schedule she had
constructed with no deviation
it held no leeway
for the pair of eyes
that touched the hymn of her slip
or for the voice
that tumbled her to his feet

She was just passing through
and his feet were there
she felt water and earth
felt his touch
his touch of words
felt
water and earth

With a brush of his hand
he had washed her
and with the touch of his eyes
he had cleansed her
she stroked the dust of long roads
from his feet

then dried them
where her tears had fallen
on his feet
she dried them
with her hair
and he was just passing through
on his way
home.

MICHAEL L. EVANS

Not All Mysteries Need Be Solved

I lost
my shadow once—
never knew when, or where—
it returned on an ocean breeze
scented
with spices from exotic lands;
it sleeps nights, 'round my neck,
in a black silk
dream-bag

FRANCINE ROCKEY

Letter to a Younger Me

Dear Little Red
little Crayola sky-eyes
little freckle-kissed
cloud-swingin' star-wishin'
lash-battin' dreamer of
plump streaming dreams

Life's gonna smack you
like a semi
Going to pop
your bubble wrap
Gonna send your guts
gasping through the muck
of the suck of it

Out of breath, you'll
want to cry and hide
with the handsome ◎
boogie-wolf-monster
under the bed
Want to run
until your legs fly

But dear Little Red
little Crayola sky-eyes
Instead
plant your feet,
bite your lip,
clasp your hands

You're made of
truck-tough stuff
So fight

DIANTHA L. ZSCHOCHE

The Cycle of Life and Death

In front of me ripe with life,
the daughter of a friend expecting her first child,
she glows I pat her stomach, a girl thing;
anticipation is palpable.
Just then the phone rings,
my husband says our nephew 22,
who 3 months ago was anticipating his college graduation,
now on life support after cancer found his brain too fertile.
Life and death,
the cycle of life and death,
you can't stop it.
You can finesse it, delay it, rail at it,
stand perplexed in the midst of it
but you can't stop it.
So how do I straddle these two poles?

With grace hugging each of the mother's in turn;
embracing their joy and sorrow.

Rejoice with those who rejoice,
 weep with those who weep. ***Romans 12:15***

Iguanas and Ice

(year five of your seven-year sentence)

3 a.m., Friday. I check in to the only motel
within fifty miles of the prison.
I shower, schedule a 5 a.m. wake-up,
 surf through Spanish channels,
and settle on figure skating.

We kiss our allotted kiss, sit facing each other
across a fiberglass table with one too-short leg.
Our first visit in two years
without glass and steel between us.

He shakes his head, says he had the strangest dream
he was ice skating—tights, sequins, the whole deal.
I choke, scatter my Skittles across the linoleum.

That night I run over an iguana
as it scuttles across the motel's gravel lot
and under my right front tire. I wake screaming
but my wheels are clean.

Security makes me an hour late for Saturday's visit,
demanding I find a sweatshirt when the arms-above-head test
reveals a compromising strip of back, hip, and belly.

We kiss our chaperoned kiss. Curse the stifling
dress code. Another young couple walks laps around
 the dirt yard.
A little girl with pink-tipped fingers traces a knife blade
inked across her father's thick neck. We lace
and re-lace our slick fingers, watch a roadrunner

chase a lizard along the chain-link fence separating us
from a dozen men lifting weights and playing basketball.
A few walk within earshot, whistle at us through their teeth.
He nods and tips his cigarette in thanks.

Did you catch the special last night on iguanas? he asks me.

The roadrunner doubles back, snatches the lizard
 in its quick beak.
Too much at once, the tail dangles out for several minutes
while the bird's stomach makes room.

C.A. Lindsay

GRASS

Brushing a blade of grass
with my finger, a plant
is dwarfed by my hand—
then an ant
crawls up its spine
and I see
how gargantuan
grass really is.

inhale

you can smoke the air in this house.
slink out of your sheet solace
and two steps later see that breath
bounce from your lips, hump
the windows as moisture meets
the air holding your exhalations,
inhalations tasting like sulfite.

you can smoke the grass in this house,
watch the Mediterranean colors sprout
through the walls, mingle with the faces
that greet you day and night, sun-shifting
with a slight, canvassed significance,
having the might, the acrylic-tact to say,
this is who I am, this is who I'll be.

you can't smoke the future in this house,
notice only how air that tastes like light
leaves when, avid, steaming, the night
hiccups a curse. the indoor palm
is dying and life for you is a collapsing
parabola, you're living on the vortex,
waiting to spring, spiral like the smoke.

some days the sun smothers the smoke
like a mother, rocking it, smoothing it,
cooing it away. it seeps back in, calm,
through the walls, your fingernails,
your nostrils, up in front of your eyes,
then it dies, and you watch the clouds
form life's blueprint in the sky.

Foster Child

Alone, skin and bones, she came to me at eight;
shoe-button eyes of pot metal gray, tarnished,
no gleam, no glee, dangling and hanging
by a fine line. Returned like unfit merchandise,
two sets of parents threw back the thrashing
little fish they'd caught, once feeling so blessed
to have snagged this smart towhead, a pretty child.
Tossed her back, finding their catch not fresh enough.

Relinquished is a devastating word
which most of us don't fully understand,
with underlying nuances of dark
closet-time or bottoms beaten or wry
words – a shiv that quivers in the air
until it scores a hit. My foster child
was tried, and convicted in two trials,
long sentences of incarceration
with "nice" families who simply could not
cope with her odd ways, or so they'd say.
Nothing too far out, the route Rebecca
took to adulthood was long. Meandering
the map folks put in her hands to follow
provided puzzles she found unsolvable.

Adoption, the destination dreamed of,
the place she could not get to from here;
how many small spirits sink instead of swim
in that storm out on the sea of tears?
I fear it's far more than we ever hear.
Most picture cooing, blond and blue eyed tots
upon their knee, you see. A Gerber Baby:
unformed, undamaged and still lovable.

Before the Fall

We cruise A&W in hand me down cars,
a gallon of gas, a pack of smokes, 25 cents.
AM radios spill Chuck Berry and Elvis
into the parking lot where carhops
scurry between Chevys and Fords
festooned with flipper hubcaps, chrome
tipped duals and Mickey Mouse whitewalls.

We comb our hair constantly, duck tails
and flat tops, pompadours that defy gravity.
The sweet scent of Brylcream and Butchwax
mingles with the stale smell of cigarettes.
We wear tight white tee shirts, lean muscled
arms draped out the window, a pack of Lucky's
rolled in the sleeve, only the wish of a tattoo.

We roam city streets, always on the move
like sharks searching for prey,
praying we'll run into those two girls
in that white Corvair, the cute blond,
her chubby redheaded friend
whose name none of us can remember;
or that chick who speeds around town
in her daddy's Dodge, willing to invite
boys into the back seat.

We pile on the miles, smoke until the pack
is empty, never give it a second thought.
We are children of the *good times*:
Vietnam still buried deep in the evening news;
that open window above a grassy knoll in Dallas,
the crowded kitchen in the Ambassador hotel,
Martin's final I have a dream, somewhere in the future.

And, everything we want only costs a quarter.

JON WESICK

Worn

Rank with the sweat of sleepless nights
my day hangs like a wrinkled shirt.

The sun a giant bloodshot eye
brews jittery tea counts the hours
until its collapse onto fresh sheets
somewhere across the Pacific.

Flesh-eating beetles
their claws clicking a Morse code of worry
swarm under my bed. Cowardly creatures
who only bite in the dark.

 jump
I & throw a book
at the dung-colored shell
vanishing into a crack
in an imagined future.
The alarm clock mocks me
with glowing numbers

Animal

You, my darling, are a rat
without a hypothalamus
you gorged on flesh, on sweets
and on the slop left over from all your conquests.
I was fooled by your whiskers, your sleek fur
and those teeth that bit into me like an iron claw.
ah, how tight you held me
clenching me in your mouth
hungry for me with your insatiable appetite.
I too became a rat
ate your raw flesh
until i burst open
the tiny eggs, those stars of love
that slimed over you.
Lost in the garbage
we fattened up
began to chew even on our own skin
gnawed on each other and ourselves
until nothing was left
not even the dust of bones.

Woman Warrior

I gaze with seasoned eyes out bedroom window
admire creamed magnolia flowers, spy the evil crow.
He jams his tortuous beak into a crevice created
by peeling palm bark some twenty feet in the air.
A determined thief, even with precarious footing
he stands poised, mangy body erect,
his head jerks with rhythmic pounding
as he rips into someone's cherished dwelling.

Certain a nest is being raided,
a baby bird torn to bits, or
maybe a den of nursing rats
ribboned and red with cruel blood,
I howl a war cry, rap on the window,
run for the bb gun to assail cloud-filled skies.
In an instant
I dispatch Mr. Crow air-mail
with a mere cock of my Red Rider.

I breathe deep the fresh air –
a modern-day Wal-Mart warrior woman.
Diana takes aim, calls the shots,
I sigh, lie back on garden cot, adrift.
Maybe, I'm no heroine today.
Still, some babes are safe in bed
for a moment.

Basic Training

In the beginning the body parts,
 small, sharp-pronged and plastic,
came in a Mr. Potato Head Kit

−the first toy advertised on TV.
 Same as Kix, Frosted Flakes
or Sugar Pops, we had to have them.

For less than a buck, we bought
 two mouths, four eyes, ears, limbs,
four noses, three hats, eyeglasses

and a dapper pipe, all for poking
 into russet potatoes. Our delight
wasn't in arranging silly faces.

No, what thrilled us was to thrust
 the spiked pieces through the skin
of a dumb spud, to smack and stab.

By second grade, attentions turned
 to Timmy Cooper whom we chased
around the asphalt schoolyard.

Timmy would weep like a girl as we
 goaded him into handing over his roll
of Lifesavers, his latest Pez dispenser.

In our surly teens, we toughed out
 dark moods with charcoal-filtered
cigarettes ("Us Tareyton smokers
would rather fight than switch"),

flicking butts and snuffing them out
with the toe of our oxblood Weejuns.

We smashed empty Pabst and Schlitz
 cans, one-handed, and lobbed them,
the arc descending into distant corners.

Drafted, we traded our floppy hair
 for buzz cuts, our jeans for fatigues,
and marched or ran for miles.

We found out how to field-strip M14s
 and pull the pin on hand grenades.
We believed we were ready.

<div align="right">

CURRAN JEFFERY

</div>

Night Sky

Once upon a quiet night and a quiet night it was
 A turquoise horse and a red, red rose
Rode around a yellow moon.
 A tiny bird with ruby eyes
Flew above the purple skies
 While dancing elves pranced and praised
And laughed and laughed and laughed
 As the dogs of hell crouched by a fire –
Howling at the silent moon.

BOBBE VAN HISE

The Spa

– for JILL

A mother-daughter day,
we join others
folded into cocoons
of radiant moon-white
terrycloth robes.
Memories of her
swathed in a blanket,
snuggled in my arms.

We wait our turn for
gifted hands that massage
and caress our bodies
while we sip water infused
with cucumber and mint.

Skin glowing, bodies relaxed
we lunch, hungry
for healthy food,
and quiet conversation;
a bond between
mother and daughter.

Over too soon, we part,
and vow to have another
luxurious, pampering spa day,
sipping water infused
with cucumber and mint,
folded into our cocoons
of moon-white terrycloth robes;
my daughter nestled in my heart.

California Cuts

In the stylist's chair,
hair thick as hope spills down her spine. Tall and
long boned her bare legs glide beneath
the beauty shop smock, draping
her shoulders in a cloud of pink.
In the mirror, my own hair half pinned,
half blown dry, I can't help peering at that
darling sixteen year old face shyly nodding the go ahead,
biting her lip, spark of a smile, as Phillip
sections off each flank, begins the hard brushing, crackling
sweet end of her childhood – Stop! I almost scream,
as he weaves lock and lock into a single braid, grabs
his scissors and in a single cut
lops off the full eighteen inches.
I'm gritting my teeth, eyebrows arched
my face acutely pinched when she catches
my eye in the mirror – Don't worry she says
It's for my Mom. . . Locks of Love, the cancer group. . .
you know, donated hair. . . and I sigh and nod and relax
and in minutes she's jumping out of her chair, fingering
the chopped ends cut from that black avalanche
of tumbling curls – and turning to Phillip as he lays
the plaited tail across her open palm, stroking it,
whispers something under her breath
as she slides it in a zip-lock bag and into her purse.
Looking back in the mirror she grins, as I watch her
innocence vanishing in the flushed light of afternoon.
I pay my stylist and step out into the street
glance through the window at the girl in the mirror –
On her lap that envelope of gorgeous hair
that will soon cascade down a woman's bare neck,
swish against her spine like a lover's touch, as they
hold each other long into the night.

NANCY STEIN SANDWEISS

Enough?

– for Bishop Paul Verryn, Central Methodist Church, Johannesburg

They lug black plastic bags,
fleeing Zimbabwe's desolation –
violence, hunger, rampant inflation.
They find Johannesburg's no Eden:
idle men and women line sidewalks
shantytowns teem with ragged children
lawlessness reigns.

Still, refugees come. Some lucky ones
find floor space in a church, hot meals
clothes for their kids. The minister
shoulders their cause, exhorts
his congregants, ignores the wear and tear
on carpets, pews, himself.

The building fills, newcomers spill
from the vestibule onto the portico.
Odor of unwashed bodies wafts
into the sanctuary, overpowers
the fragrant floral piece.

A wary church deacon sidesteps
bedrolls, spots his frazzled minister
surrounded by beseeching eyes, asks
Haven't you done enough already?

R. D. SKAFF

Glassenheit (Amish Humility)

Bound
in a bun she never sees,
uncut strands of salted flames,
long sleeves, long skirt,
apron fastened with straight pins,
faith fastened with family.

Adult child of eighteen,
she chose to return a decade ago –
Rumspringing from:
revelry to barley.
TV to quilting bee,
new wave to no refrain,
raggedy Donny
to faceless rag dolls,
rose-scented hot baths
to buckets of bitter chill,
lapis and lights
to the ring of a dark church.

She tucks-in paisley squares
around her nine-year-old's
dark nightgown,
blows out the kerosene lamp,
recalls
pumpkin-spiced candles,
a story she never tells,
Tucker beside her in
a faded sunflower futon.

FRED LONGWORTH

Death

It stalks me not as a slavering blob
of fangs and tentacles on loan from *Alien*.
Not as the thing that crouches
in the underbelly of a child's bed.
Not as the product of a father's fury
and half a pint of Jim Beam.

It stalks me as a cul-de-sac of time,
a covenant in blood for the purchase
of a youth, a blade that rips and rends
the fragile membrane holding sentience in,
and lets one tiny drop of consciousness
flow back into the sea.

ANITA CURRAN GUENIN

The Hopeful Blouse

1.

The box of clothes
rescued from a flooded
Katrina house
rests in our garage,
no further place to go
since their owner,
not knowing who
or where she was,
died last year in Alabama.

I put polyester blouses, slacks
through a fragrant wash,
partition them into bags
for refugees, homeless women.

Except, I keep the blouse
splashed with spring flowers.

2.

Handkerchiefs

Delicate linen
washed by Katrina's acrid waters,
bright embroidered blossoms,
butterflies, survive
in their forever world

Some have monochromatic
initials on corners, framed
by leafy thread flourishes,
all that remains
of "M" and "C"

CHRISTINA BURRESS AND MICHAEL HORVITZ

A Collaborative Piece

– The universe is made of stories, not atoms. – MURIEL RUKEYSER

And yet the atoms have a tale to tell –
May they not share the universe as well?

Ancient miracle of threads unfurling
Diverse voices murmur in their whirling.

What do these murmurings you hear demand?
Is it a language we can understand?

Awaken to the ubiquitous play
it says, in the language of convey.

Convey...so much emotion in that word.
But how might I awake to what I've heard?

At day's break you must listen deeply
Subtle missives rise from earth sleepily.

I listen, yet all words come in disguise –
a language writ on clouds in cloudless skies. . .

Really? Have you listened to unseen notes?
Or have you assumed obvious writ quotes?

Assume the obvious? – No – that's not me.
But all the notes I listen to, I see.

I understand. Let's say you close your eyes
and silence reigns? What notes see you now rise?

The first note says my poetry is frail.
The next declares, "Persist, or you shall fail."

Sometimes ego barges silence's notes
Best to suspect these rude quibbling votes

But if my ego barges into verse,
Then I'd suspect that silence is a curse!

Ego invades all space with equal force!
Accept it and keep the lyrical course.

Yet, if my ego seeks poetic fame,
might I succeed? or would I fail in shame?

And would I have myself alone to blame?
Or may I fault the audience who came?

<div align="right">

ELIZABETH YAHN WILLIAMS

</div>

My Reign in Spain

He's giving up his hike today
 To meet my plane.
I've been away;
 And, perhaps, missed?

He's baked a honeyed cherry pie
 And vacuumed fleas
 And washed the cat;
 And wondered, while
 I roamed the seas
 With other artists,
Have I kissed?

Sometimes we need retreats in Spain
To find our way to love again.

Daybreak

In the shadow of Denali
just before dawn,
a grizzly with two cubs appears,
seeking the last dried blueberries,
calling her family to follow,
keeping an eye out for a winter cave.

In a glacier pond
a moose pushes its nose
down into the water,
pulling at the roots
 of water plants,
bulking up for rutting season.

A herd of caribou flashes
 across the tundra,
regal in their carriage,
racks of antlers gleaming,
fading from sight
as hooves clatter across dead rivers.

White spots on mountain high
wake from slumber,
munch on sparse grass.
Dall sheep, pompous in the knowledge:
no need for color-coat change –
enemies can't climb mountains.

Gray wolves take the Park roads,
preening in coats beginning to
 thicken, darken, winterize.
They're looking for breakfast—
arctic squirrels are best,
but they will settle for anyone's eggs.

Mornings in Denali,
sunshine touching the peaks,
wildlife getting ready
for the first snow soon to fall;
each night
the Northern Lights put on their show.

JAN GALLAGHER

Advanced Degree

I have an advanced degree.
I majored as a madness trainee
I watched paranoia and fear intensify.
I looked it in the eye. . .the eye. . .the eye

He never wanted to cause us pain
But we cringed when his voice changed,
Became Biblical, epoch, magnificent.
As he roared curses, cruel, vehement.

I have an advanced degree
I know all about insanity,
Disease, genetic wiring gone awry.
I just don't know why. . .why. . .why

JOANNE D'AMATO

My Uncle's Little Butterfly

– The sun, with all the planets revolving around it, and depending on it, can still ripen a bunch of grapes as though it had nothing in the Universe to do. – GALILEO

There's an early memory seeded
not in my mind but deep in my soul.
A place where my spirit rests
and my dreams breath.

A memory of a girl of four
standing under a canopy of vines.
Orbs of blushing purple laced with
those of adamant chartreuse. Too high
above for my small fingers reach.

My young eyes follow flickers of light
as the sun winks to me, through
tangled branches and loafing leaves,
curious to find the trail's end.

Dancing around my frail arms flap;
Wishful - I await a rustle to the trellis.
A welcome breeze to flutter my wings
gliding me up to the grapes.

"Oh so there you are my little butterfly"
Uncle Charlie calls out to me. Knowingly
his strong hands lift me up, fly me high
so I can pluck a sun warmed globe off
the vine, its juices bursting in my mouth.

I was always my uncle's *Little Butterfly*
from that day forward. I carry the memory
of fulfilled joy nestled in a place between
my soul and my dreams. And I smile.

DIONNE BLAHA

Flying

When a roshi sits next to you,
do you reach for the brake-cord?
The pull-down stairs unfold,
she waits for your answer,
and instead of wondering why she wants to know,
you let the sand fall back
into the sea.
It doesn't take much sugar
to make cookies
or ants happy.
But you keep wondering, where is the end
to the grocery lists,
children to deliver,
wasps to shoo away,
weeds to pull from
the planned cracks
of your otherwise perfect sidewalk?
Spiders still traipse across your attic
while you sleep.
Here's a hint.
Don't cheat.
The birds will fly straight.

MARGE PIERCY

Feeling better?

Pain hollowed me out from within
no desire except that it stop
no thought but that it went on
and on and on.

Now waking from pain I dance
in the light like a dust mote,
suddenly light, mobile
suddenly free.

I am wisps of milkweed fluff.
I am dandelion seedheads dispersing,
foam tossed from a breaking wave.
I weigh less than air.

My senses slowly open
their trumpet lilies. I am clear
as a perfect blue sky whose sun
rises inside me

and I burn with possibilities.
I am the best gift I've ever
been given, to re-enter my life,
a homecoming parade of me.

CHRISTINA BURRESS

A Photograph of A Farm Called "Favorite"

In this photograph the land looks alive
There is a red roofed barn
Enclosed by wood fencing
Tails swooshing on donkey,
Horse and pony. Chickens roosting
A white goat posing a top a bench
Serene green foothills
Punctuated by granite and pine
Clouds, an immeasurable sheet of clouds
Pulling toward me
Then suddenly opening to reveal
A blue holed fantastic

But a photograph is only part of this story
There is also the break in heat
After a summer thunderstorm
Flies pestering rump and nose of sorry beasts
Helpless baby sparrows begging for food
Cooper's hawk chased and tagged
By the red-winged blackbird
Chimes, train, and ambulance
Layering the wind
Three teenage girls
Plying their hair
Into soft pink rollers
A black dog
Frozen over a rabbit's burrow
And the continuous
Spin of the ceiling fan
Moving a mountain of humid air.

I Teach Him My Polish Name

three birdlike syllables, and look,
leaf shadows of Warsaw
fly across our faces –
It's October and so effortless

you'd think we've had
leafy conversations endless times –
when it's been decades
since I last said "Nietzsche" in bed.

I feel his presence then, the long-ago
lover who knew all the words I knew –
as if he and I were still
murmuring in that nude half-tone.

And another also wants to
lie down, tired after dying
and so young, I hardly need a son
to teach me tenderness.

Leaves are only beginning to flare,
waves of color hidden in the night,
and I don't yet know
this autumnal lover's first coming

will enter every doorway of my mind –
his come-cries so much like sobbing,
at first I think he's weeping.
He cries on and on, enough sobs

left over for my life, and the lives
of others with us in this room,
their shadows interrupting moonlight.

R.T. Sedgwick

Cafe Chemin de Fer

oranges and lemons, oranges and lemons
market square filling with faces
just off the waiting train

a light rain graces
impressions
apples and pears

the train sets in motion
huckleberry, huckleberry, huckleberry
plum

dark plum
plum preserves
spread on cradles

of broken baguette
may I pour more tea?
please, I light her cigarette

she fiddles her wide-brimmed hat
smoothes the clean white cloth
selects a bunch of grapes

offers me one and swizzles it
across my lips before
inserting it

her eyes dark as grapes
as plums she stirs my tea
with honey smiles

how detailed the dream
and yet
I neglected to get her name

oranges and lemons, oranges and lemons
huckleberry, huckleberry, huckleberry
plum

PAUL A. SZYMANSKI

Where the Universe Begins

Three saw-toothed steps
Behind the stucco cracker-box
Open to the fruit trees,
The hoop on the garage roof,
And a huge orange cat named Moose
Whose green eyes glint when I
Flick on the porch light.

There the moon starts its hunt for the sun,
Distant spheres of light emerge,
The earth yields its heat,
The planets bee-dance in waves of light,
Electrons crowd out space,
And from the orbs' vibrations:
"Let's go! No time to lose!"

It was there, on the back porch,
Under the useless yellow bug light,
Where the universe begins.

CLAUDIA POQUOC

A Hot Night with Neruda

– And now we will count to twelve and we will all keep still.
– PABLO NERUDA

Well, Pablo,
Here we sit, still,
having counted way past twelve.
Fishermen are still "harpooning the whale,"
those who prepare for war
still "fighting for victory with no survivors,"
I am still riding the dragon's tail
of a chilling wind,
while we struggle to ignite the word
before the icy god of oblivion.

Our human hopes
clenched in this god's frozen fist
must be released by our steamy breath –
this breath – that weaves fragile webs
to catch new life.

Perched on your poetic branch of being,
amidst ice-capped feelings,
I burn to be.
Feeling the ache of intonation
your hot rhythms scorch my tongue –
inflame my need to speak.

Your stillness moves within the
depths of my half frozen soul.
I hear the hiss of melting ice.

Long before the sound enters my inner ear
I *will* – my life – be given.
The burning word fights the dragon's breath.
I can keep still no longer.

orange you glad

we had an orange slugbug
in el cajon.
a 50/50 bar tugging
down mollison.
the windows never
rolled up right,
so I could monkey
my way inside
and bumper car
myself to disneyland.

we left it in san diego
with the sherbet sunset.
got a newly used one
in north carolina
with a hole in the floor
behind the driver seat
that my face
could fit through.
the metal frame
wanted to shed
the red paint
like too tight dead skin.

one winter night
with the frozen forest
folding in around us,
papa stumbled through
the front door,
drunk as usual,
and expelled fire
from his booze
burned throat,
a single fist
connects to her face.
my mother is standing
in our living room
with blood trickling
from her nose
like a silent,
aching stream.

the next day
we rip away
in the bad omen
and I look down
through the hole
at the asphalt blurring
under my gray mary janes,
a stained snowflake
trail in our wake.

La Tormenta

In late July Carlos wheels off the road
under darkening clouds and crackling sky
crossing into trackless night

Jack rabbits scurry from *cholla*
to *ocotillo*
dashing in and out of cosmic light

Under a granite cliff on Indian hill
sharing time and space with Ancestral spirits

Reclining on white granite we watch
flashes of lightning loop and leap
across the brooding southern sky

Daggers of light randomly strike
the sable bosom of mother earth

Our eyes wide open in wordless wonder
on a barren rock in Anza Borrego

 La Tormenta: The Storm

KATHLEEN PECKHAM

Small Town Christmas, 1921

Since I was young
I've worn hand-me-down shoes
from Swedish cousins
always black or brown
scuffed and torn
molded by their wide feet
and smelly.
I've covered two oranges
with cloves
to put in them at night
clean them with a brush and soap
but it doesn't help.
Whenever I can
I tuck my feet beneath my skirt.

This Christmas the principal promised
the school board would give
each of us a gift
if we wrote our choice on a list.

I carefully considered all I've seen
in catalogs and on shelves
dreamed the whole school break
about new saddle shoes size five.

Now in front of the entire school
you tell me
because my father drinks
they bought me nothing.

POLINA BARSKOVA

From Mad Vatslav's Diary

I was a coal-miner, water
Poured over my gray hair, my eyelashes.
My sister, alive and laughing,
Shepherded such glorious cows!

I was a soldier, and afraid of living
I did my best to die – but did not manage to stumble
Upon any bad luck. The tsar's own daughter
Visited my cabin and gave me a magic rope.

I was a slave. My master's wife
Adored us, the dark, forbidden Slavs.
The green sunrise was the strangest.
In sorrow I danced, swaying, trembling, on wooden porches.

– translated by KATHRYN FARRIS and ILYA KAMINSKY

SARAH B. MARSH-REBELO

Sabers

There is something suspicious about a shaft of sunlight
that cuts across a bed
slices the room like a gold saber
the one without conscience turns in untroubled sleep
the other throws back curtains
bathes in the alignment of her senses
aware that this gift for one moment
makes sense of the world.

TERRY SPOHN

nowhere the body

the old school's hallways constricted like arteries
mother got shorter and her clothing shrank in the closet
we once thought the world got smaller as we grew

now we're told the universe is expanding instead
everywhere things move away from one another
the way bread dough rises in a summer kitchen

the tomcat's ears grow farther apart
children leave parents and the phone goes silent
bones in the earth lose interest in one another

your friends' names etched in the black wall
but their faces fade in the red shift of memory
until only a thin lozenge of wonder remains

in the early morning light the lost girl
seems to appear but she's gone, too
everywhere her face but nowhere the body

she smiles to us as we walk the dog
her cheekbones wrapped around light poles and limp with rain
stretched across banners on the high school fence

gaunt women and men hold their cigarettes out
the windows of green Toyota trucks
their faded bumpers say, help us find her

we love you they say, please come back
to this bright unbroken future
this place we can never go

UNA NICHOLS HYNUM

Second Thoughts

In a painting everything stands still
like children playing Statue on the lawn:
waves hold up the green glass
of their breaking, a red glow pauses

on the lips of dawn. On canvas
no one hears the growl of thunder
or smells the acrid sulfur of a strike.
The brush unblinks a jab of lightning

as a suicide might wish to stay
his flight. The artist decrees
the rain will stiffen, a ship forever
founder on the rocks. He stalls

the revolutions of the lighthouse.
With one decisive stroke the sweep
is caught. But there's no way to stop
the jumper, leaping, though his mind
back- pedals madly to the thought.

GWYN HENRY

Persephone and the Deer

I feel old now, and as my mother left for the underworld, she seemed young, slipped from her body as easily as the heart of a deer into the hunter's hand.

She died just as five black crows broke from the pasture fence, five carbon flakes against the window pane.

As she lay dying, we switched places: she became Persephone, the daughter, and I Demeter, her mother-- and afterward, it was me left alone on the surface, while she'd gone
Underground.

December lives here now & I can't get warm in this country of ice that shatters trees, of frozen power lines and heartless hearths. Ice water drips from each eave, as well as from the absence called Sky. A frigid hand seeps into my socks, finds the flesh of my toes, fumbles beneath my bra to hold my breasts in its bloodless fingers. I can't get warm.

My mother's cement deer stand outside beneath her shattered trees, frozen as always, even in summer. And as always, they stare. Today it is through the rain, and how impervious they are to the void she's left. They don't even wonder how long will she be gone, or if she will come back in the spring.

But I wonder, will she be curious about the deer's 40-year stares, now frigid with ice. Will she ask if they feel the cold? Will she be envious if they can?

& now that she's gone, will her deer finally lower their gaze to search for the tender blades of other seasons? If they find none, will they know at last that what they thought were roots, no longer require them to pose for her pleasure beneath the trees? Will they lift their cement hooves, and move at last from their planted places?

& if she resists the pomegranates to return, will she follow their footprints to higher ground?

HOPE MEEK & JOHN WEBB

Temple Bells

The bronze bell hangs
from temple beams,
hums in the wind.
The grey log swings.
Vibrations of a thousand years.

MARTE BROEHM

Homesick

I was sitting alone again at the round table in the sunroom of the inn and thinking about my dream from last night and how I've been flying more in my dreams, flying again, once more, as much or more than when I was a child. My arms spread wide or straight above my head as if goal posts and my body moves up, purposeful, no effort, I just rise into the trees or to the edge of a building. Sometimes I fly in a swimming fashion, the breast stroke, yet slow, rhythmical, without sudden breaths. Last night I was wearing the blue empire dress I sewed in 7th grade, its long sleeves rippled with wind at the cuffs, and barefoot, my hair long again, more blonde as in my youth, yet I was 50-something, flying across Newberry Street, above Angels Restaurant, over the College Avenue Bridge, stopping at the top of a full elm in Judge Van Sustren's yard, and I stood on October's changing leaves as if I were made of feathers, lightweight and free, the Fox River below me pounding through the locks. People walking and driving could see me, yet most paid no mind, making of me nothing special. I stretched my arms out and down, walked parallel to the river against its flow, walking north, the grass soft and damp, and I could feel specks of water come out of the river, lighting on my skin, sparkling as if silver, and I returned to the Riverside Cemetery, to black wrought iron and strong red brick.

SERETTA MARTIN

Intensive Care

– for UNA

O, the sick are such dreamers–

See how rain takes us
in its chest of clouds
and carries us into
this fragment of day.

We must catch a cab
from one storm to the next,
wade through puddles
with no umbrella.

The sick tread like clocks
between hours and morphine,
float, forget heart beats.
At this moment, can they tell

drops from hail,
a nurse from next of kin,
an IV drip from memory
of a walk in the rain?

Don't ask questions,
don't call them back,
they leave you alone
to watch and wait,

holding a mirror
until they return.
See how breath
leaves us with rain?

Alone

I've lost him.
And I'll never be the same.
It hurts
deep
and lasting.
I cannot or maybe it's just I will not shed tears.
My body won't cry,
my mind weeps,
alone,
and unheard.

We met in the middle of a far off country
in the middle of a war,
in the middle of nowhere,
in the middle of forever.
We traded futures,
laughed at our pasts.

I buried them last night.
Our dreams mingled with memories.
He was back from the war just eight months.
He'd lost his dreams and had forgotten the past.
He shot himself.
All alone.

MARLYS COLLOM

The Diagnosis

Attempting to break into a closed system
I wait for you in the waiting room,
 upon arrival you send me away.
Finally you call, "I have cancer",
 the words a hot poker in my gut,
I can barely breathe. I need to see you, to be with you,
you want to be alone, crave solitude, you hang up.

Five days go by without a word.
I've known you since I was fifteen, I don't intrude.
When your third friend died from this disease,
you swore you'd refuse treatment, said you would
gas up the boat, head out to sea, pull the plug.

Forty years of marriage have prepared me,
you like to walk troubled roads alone.
When you allow it, I become a drop in guest.
Day six, I call your cell phone,
"Have you gassed up the boat?"

"Yes, but I haven't taken it out yet."

"Are you ever coming home?"

"Yes, if you won't pity me."

I call the children, tell them the ground rules.
Michael breaks the ice with a phone call,
"Daddy, do I have to wait until you die before
 I get your tools?"

From then on we handle this with gallows humor.
The cancer support group doesn't like
 our coping method.
The leader asks, "How are you dealing with this?"
I answer, "I've written my singles ad,
 but haven't placed it yet."
You tell them about your escape plan.
 Aghast, no one even smiles.
We grab their cookies and leave.

Two surgeries, fifteen months of chemo,
once again you're a survivor.

ROGER FUNSTON

Grandpa Saturdays

He is dressed in blue blazer
Dress shirt, frayed cuffs
Stained gray slacks
Bad haircut
Stubbly gray beard
Vacant look

The monotony of the facility
The loss of independence
Scheduled showers, three days a week
He is still able to walk
Comes and goes, sneaking in brown paper bags
Alcohol his only friend for dulling depression's pain

Twenty years ago he was full of life
He used to walk so fast I could hardly keep up
Rolled a mean backhand hook at the bowling alley
Root beer floats made with secret ingredients
Cards dealt from the bottom of the deck so I could win
Thinking I didn't know
But I knew. . . I knew

I hear the slur in his voice when I call
I think he knows who I am, but I'm not sure
I want to be there for him
Repay him for his love
At a time when this was scarce in my life
And put-downs plentiful
But I am twelve hundred miles away
Beginning my career rise
As he slides towards his demise

SUSAN HOGAN

A Memory

One day in the Semya Park in Moscow,
(O that Russian park where all the women
Are chasing around their blond-haired children!)
I heard somebody tuning a balalaika,
And quietly singing a scale, just to himself—
And I saw him from across the park tightening
the strings as he warmed up his throat.
Then he began to sing openly, strumming.
His gruff voice carried a melody through the park.
As the families played in the late July sunlight,
A young man played folk songs beneath the silver birches.

Violet and Sadie

My mother-in-law Sadie, ironed her sheets
with a small mangle she kept in the basement.
Her sheets were twenty years old by the time
I slept on them. Smooth and crisp at first touch
they dissolved into a tissue of wrinkles by midnight.

When buying sheets look for one hundred percent cotton
lest you wake up at two a.m. sweating and fretful.
When shopping with Violet, race ahead and tell the saleslady
you want she-e-e-ts before mama asks for *shi-i-i-ts*.

This morning Violet and Sadie occupy
the same dream like the interlocking parts
of *yin* and *yang*. Sadie shows me how fast
she can run, falls, but picks herself up. This is not
the woman I knew, heavy-boned, slow to move.
Things must be different in the spirit world.

Mama says *I'm giving you a clothes bag.* I lift the bag,
light, smelling of cedar like the folds
of silk in the Chinese chest. Lemon yellow
embroidered with butterflies, pale blue
beaded with flowers. Not enough to make a dress.

Enough to embrace, to feel
with your fingertips the smoothness
of silk, hold it under your chin.
Imagine yourself young again
your skin like placid water
under a tranquil sky.

Go

– translation by Seretta Martin

I pace back and forth. . .
turn, and set my eyes on you
who never were, who'll never be –
a starling hermit
nestled next to me,
a lecher, a monk, an albino

the night prowls like a cutthroat
and smothers with its grave blackness.
I am an abscessed hive of a soul –
my one and only enduring desire:
to defeat despair and bit by bit to go,
but where?. .

Išeit

pirmyn, atgal, pirmyn. . .
apsisuku, akis į tave įremiu
esi nebuvęs, neesantis, nebūsiantis,
apsigyvenęs mano inkile
varnėnas atsiskyrėlis –
ištvirkėlis, vienuolis, albinosas

tartum žudikas sėlina naktis
ir užgula visu svoriu juodybės
esu žaizdotas sielos avilys –
vienintelis nesunaikintas noras:
įveikti neviltį, lėtai iš čia išbrist,
tik kur?. .

TRISH DUGGER

Hephzibah Home for Children

You took me there
and left me.
I couldn't know
it would be forever.
I knew nothing
about time, only the feel
of your lips on my cheek
when you said goodbye

Tulips in bloom,
so it must have been Spring.
Lilies-of-the-valley
crowded a side yard,
thick sweet scent so close
it made me dizzy, breathless,
like your whisper in my ear.
Be good. Be brave.

Stunned snowball bushes
dropped their blossoms
when you left,
as if a sudden cold snap
had attacked,
a blizzard of white petals
falling on the ground.

A snow globe turned
upside down,
my world turned topsy-turvy,
and in the side yard,
the silence of tiny white bells.

KRISTEN SCOTT

The Shoveler and the Dreamer

a Shoveler dangles quizzically above the sand
and screams perched upon the slightest piece
of cement, rubble from the last air strike –
covered in white phosphorous, it clings for breath
as it looks for somewhere to spread,
and clean its injured wings–
underneath the cracked mortar, a child lies,
so perfect as if asleep,
eyes are wide-open.
still, bird believes she dreams
of macaws , *Arabian Nights,*
and ruby slippers
the Shoveler sucks in vaporous
air breathing it into injured breast–
it swells like a blossom,
releases and whistles
an enchanting song
as if to awaken
a final melody for each

Sam Hamod

Digging In: A Woman Planting

to watch
a woman tending to her garden
takes patience most men do not have
but to watch the way her hands softly cup
the ground, the way she sifts the black loam
tendering sprigs of tomatoes into
the softly responding openings, with her
breasts lowered, and her eyes fixed
she breathes with abandon, while I
feel her breath against my neck, her
quiet, probing hands, her lips
planting themselves against my
throat,
unable to utter anything more than
sounds of yielding, as the ground
yields under her fingers, so
does she promise a richness
of unending cycles of planting,
yielding flowering,
so then does my heart yield,
 on this late June
afternoon, the sun burning
into my yearning

CONTRIBUTORS
POETS AND TRANSLATORS

Deborah Allbritain is a Speech Pathologist in San Diego County whose poems have appeared in *Autism Digest, Perigee: Publication for the Arts* (Winter 2010), *Stand Up Poetry: The Anthology, The Antioch Review, the Taos Review, Cimarron Review, San Diego Writers* INK *Anthology, New York Quarterly* and various online publications, including *Poets & Poems.* Her chapbook, **The Blazing Shapes of this World,** was published in 2003 (Laterthannever Press).

Linda Engel Amundson lives in Rancho Bernardo, keeps an arbor, makes jewelry and is a member of the Pleasures of Poetry Workshop. Her work has been included in **The San Diego Poetry Annual** since its inception. She contributes to *Thunderclap Press Magazine.*

Karina V. Balderrábano was born in Tijuana in 1969. With a degree in Communications, she has worked in education, journalism and cultural promotion. Her poetic work has been published in Brazil, Argentina and Cuba, in *Nuestra cama es de flores / Our bed is made of flowers*, the anthology *La Mujer rota-The Broken* Woman and won third place in *Los Juegos Flores de Celaya, Guanajuato.* In 2008 she published her first book of poems *Palabras de mi piel / Words of my skin.* She teaches at universities in Tijuana and writes for the magazine *TijuaNeo.*

Dylan Barmmer appears for the first time in the **San Diego Poetry Annual.**

Polina Barskova is considered one of the best young Russian poets. Born in St. Petersburg (renamed Leningrad from 1924-90 and a symbol of Nazi brutality during World War II), she is professor at Hampshire College, earing a PhD from UC-Berkeley. Her latest book of poems is *The Lamentable City* (Tupelo Press: 2010).

Dahryn Bell studies Literature & Writing at CSU San Marcos and has work forthcoming in *The Quarry Review.*

Bobbie Jean Bishop's poems have been published in two Doubleday Anthologies in the 70's, in *Country Women, Mosaic, Greater Golden Hills Poetry Express, Gila Review, New Kauri, Amazon Quarterly, Rio Grande Review, Cold Drill, Tidepools, Magee Park Poets, Oasis Journal,* and a few sundry newspapers.

Dionne Blaha would be a secret poet without the encouragement of her writer husband, Terry Spohn. They live in a quiet home that brims to the windowsills with words. This is her second appearance in the **San Diego Poetry Annual**.

Marte Broehm is a poet, visual artist, and prose writer who lives in Escondido. Her poetry has previously appeared in *Pedestal Magazine, Perigee Literature for the Arts, The Magee Park Poets,* and the **San Diego Poetry Annual**. Her watercolors have been displayed at local art galleries. A piece of creative nonfiction will appear Spring 2011 in *The Los Angeles Review.*

Julie Brossy is a fiction writer who has worked as a journalist in Haiti, Hong Kong, Tijuana, San Diego, New York and Washington.

Cheri M. Bentley-Buckman, a native of Texas, attended the Idyllwild Summer Journal Writing Workshop and the Summer Poetry Program. Her work has appeared in the **San Diego Poetry Annual.**

Christina Burress is founder of The Del Mar Writing Project. She holds a MFA in Creative Writing from Naropa University. She has been published in the ezine *NotEnoughNight* and journals: *The Alembic, Admit Two,* and *Coe Review.* (delmarwritingproject. com)

Michael Burton is currently a student living in San Diego, California. He has been published in **The Renaissance** (2010). This is his first appearance the **San Diego Poetry Annual.**

After spending a good part of his life in Tijuana, **Francisco "Pancho" Bustos** now lives in South San Diego. He writes, plays music in a band called Frontera Drum Fusion and enjoys spending time with his family. He teaches writing at Southwestern College in Chula Vista.

Amaranta Caballero Prado, born in Guanajuato in 1973, holds a BA in Graphic Design and an MA in Cultural Studies. Her published books include *Okupas* (Letras de Pasto Verde: 2009), *Todas estas puertas* (Tierra Adentro: 2008), *Entre las líneas de las manos* from the book *Tres tristes tigras* (Conaculta: 2005) and *Bravísimas Bravérrimas: Aforismos* (Editorial De la Esquina: 2005). She has lived in Tijuana since 2001. She loves to draw.

Elia Cárdenas S., a Mexican biologist, has published her work in anthologies in Mexico and Spain. Her short story *Miramar,* and her poem *Símbolos,* won honorary awards in Ensenada's Juegos Florales literary contest in 2003. Her poem *Misionero* won second place in the same contest in 2006. (Bioelia@hotmail.com)

Sandy Carpenter is a former columnist for Gannett and Freedom newspapers. Along with her novel, *Casa Verde*, (Rubenesque Romances: 2001) and autobiography, *Sandy Paths* (Infinity: 2003), she has had poems published in two dozen journals, magazines and anthologies including *The Writer Magazine*, three times. (sandisea@juno.com)

Róber Castillo (Roberto Castillo Udiarte), is a teacher, translator of poetry, father, grandfather, wine lover and sometimes a poet. He has authored several books of poetry and prose and is the Editor of *Our Bed is Made of Flowers*, an anthology of women's erotic poetry and *That Night the Sea. . .*, an anthology of sea poetry, both from Baja California.

Paul Colaluca claims to have always been a poet at heart, hoping to create a space where gentleness and compassion can be expressed and experienced. This is his second appearance in the **San Diego Poetry Annual**.

Jihmye Collins is a founding member of African American Writers and Artists & Writers Inc., San Diego, co-hosts Open Mic @ Spacebar Internet Cafe & Coffee in La Mesa, and is the author of two books of poetry.

Marlys Collom attended SDSU where she was instructed by Simon Ortiz and Jay Linthicum. Her poetry has been published in *the San Diego Times Review* and in the *Journal of Contemporary Poets*. She lives in Valley Center, where she writes poems that express her inner and outer life and capture the feeling-tones of her memories

Lucio Cooper was born and raised in the Mission Beach. His work has been featured in the *Sand Canyon Review* and the *Burning Shore Review*. He lives in El Cajon with five little neurotic dogs.

Patrick Cox is a disruptive technology analyst who has worked as a script consultant in Hollywood. He has written policy-related articles for *USA Today, The Wall Street Journal* and other publications. He lives on an island off the Gulf Coast of Florida.

Jhonnatan Moises Curiel Sedeño, born in Tijuana in 1986, holds a BA in Communications from Universidad Autonoma de Baja California. He has published two poetry books: *Estival* (2006) and *Crónica de unos zapatos* (2008). He was part of the Fund for Artistic Creation Incentives (2008-2009) in Baja California and is a co-founder of Colectivo Intransigente in Tijuana.

Joanne D'Amato enjoys writing poetry and short stories. Her work has appeared in the **San Diego Poetry Annual**.

Tyler Daughn was born in San Diego in 1988. He enjoys music, especially blues, and plays with the Space Nature band in San Diego. He recently spent six months in Mexico.

Billie Dee makes her first appearance in the **San Diego Poetry Annual**.

Barbara Deming is the owner of the "I Can Write. Can You?" workshop for children and adults. Her books are *Pink Poodle Pie (Other Tales of How Women Get Even)*, *The Quilt Maker* and *Growing up Barefoot in the South*.

Ray Clark Dickson, the first poet laureate of San Luis Obispbo, is now in his 90's and still writing daily. A jazz drummer, his beat-inspired work debuted in *The Wormwood Review, The Beloit Poetry Journal* and *The Saturday Evening Post*. His first book of poetry, *Parlando*, was followed by *the press corps of xandau* (iUniverse: 2007) and *Wingbeats After Dark* (Red Hen Press: 2009).

Trish Dugger, poet laureate of Encinitas, has been featured at Border Voices Poetry Fair in San Diego and in poetry slams. Her poetry appears in various anthologies, in *California Quarterly*, *Spillway* and **Hayden's Ferry Review**. Her poem, *Spare Parts* was featured on Ted Kooser's americanlifeinpoetry.org in 2008.

Marvin Durán was born in Tijuana and currently resides in Mexicali. He has worked on the literary scene for more than 18 years in fanzines, newspapers, magazines, publicity, reality shows and, more recently, on his personal blog (marvinduran.com).

Anne-Marie Risher Dytewski claims she flails about to find expression, labeling poetry the dance, disappointment the fodder.

Michael L. Evans is a native San Diegan. He attended Chula Vista schools, graduating from Mt. Miguel High School before earning a degree from San Diego City College. His work has appeared in the **San Diego Poetry Annual.**

Donna Faith is the pen name of Donna Faith Koski. Born in Wildwood, NJ, she moved to San Diego in 1952, where she attended high school and college. Her work has appeared in *The National Library of Poetry, Poetry.com* and *Sparrowgrass Poetry Forum.* She was awarded first place in a Browning Competition (Iliad Press). Her five grandchildren, from her five children, often read her poetry at school.

Hadia Farfán is a cultural promoter, co-producer and co-host of the radio program *Letras al aire.* She has participated in a number of collective poetry readings. Her work has appeared in magazines and several anthologies in Mexico and the United States.

DHR Fishman has been published in *Cherry Blossom Review, Contemporary World Literature* and *Lucidity.* He served on a panel of judges for the first two editions of the **San Diego Poetry Annual**.

Ryan Forsythe is a writer and artist from Cleveland, now attending the MFA program in Creative Writing at San Diego State. His poetry was named Best in Show at the Del Norte County Fair and his fiction has been nominated for a Pushcart Prize. He lives in Alpine. (ryanforsythe.com)

Daril Fortis was born in Tijuana in 1988. Poet, writer, cultural manager, he co-founded the Ebano Blanq Arte y Cultura organization. He has participated in literature festivals and given book presentations at city fairs. He is currently a member of the Colectivo Intransigente.

Janet Foster makes her first appearance in the **San Diego Poetry Annual.**

Diane Funston earned a BA in Literature and Writing at CSU-San Marcos. She co-founded the women's poetry group SILK in North County. She moved to Tehachapi, where she founded the poetry group, The Third Place. Her poems have appeared *in Magee Park Poets, GUTS, Cabbages and King, Antelope Valley Anthology* and the **San Diego Poetry Annual.**

Roger Funston makes his second appearance in **the San Diego Poetry Annual.**

Jan Gallagher lives in Old Escondido. The flowers, herbs and trees surrounding her home attest to her passion for gardening. In addition to poetry, she is working on a mystery novel. Her first novel, *Ashes of Evil,* came out in 2010.

Kennedy Gammage has degree in English from UC-Berkeley. He resides in San Diego. (travelogorrhea.com)

Olga García is a Regional Editor of the **San Diego Poetry Annual.**

Alfonso García Cortés was born in Tijuana in 1963. A graduate of Ibero-American University in Tijuana, he began his present work at the School of Humanities of the Autonomous University of Baja California in 1997. His poetry books are *Recuento de Viaje / Account of a Trip, Elegías Postergadas / Delayed Elegies* and *Llanterío.* His work has also appeared in several anthologies, including *Piedra de Serpiente / Stone of Serpent* and the bilingual *Across the Line / Al Otro Lado.*

Lauri García Dueñas, born in San Salvador in 1980, is a writer and journalist currently residing in Mexico.

tomás gayton was born and raised in Seattle, the grandson of African American pioneers. He began writing verse soon after graduating with a Juris Doctor from the University of Washington. He is a San Diego Civil
Rights attorney and world traveler. *Vientos de Cambio / Winds of Change* (Poetic Matrix) is his most recent book of prose and poetry. Others include *Yazoo City Blues, Time of the Poet, Dark Symphony in Duet,* with the late Sarah Fabio, and *Two Races, One Face,* with John Peterson.

Rachel Gellman, a Bay Area native, is earning her MFA in Poetry at SDSU. She enjoys cooking, exploring and is a big fan of kickboxing.

Joan Gerstein began writing poetry in elementary school, but only since she retired as an educator and psychotherapist has she had time to hone her craft. Born in NY, she moved to California in 1969 and has lived in Oceanside for eight years where she makes mosaic pieces and fabric art.

Mai Lon Gittelsohn lives in Del Mar, where she leads memoir writing classes for seniors. An elementary school teacher in Del Mar for 23 years, she now enjoys writing in Harry Griswold's poetry workshop and singing with Villa Musica. Her poems have appeared in the *Patterson Literary Review, the McGee Park Poet's Anthology,* the *WritingItReal* website and the **San Diego Poetry Annual**. A fifth Chinese daughter, she grew up in Berkeley, relocating to Del Mar in 1971.

Laurette Godinas was born in Liège, Belgium in 1972. She graduated in Romance Philology at the Université de Liège and obtained her Ph.D. in Spanish Literature from El Colegio de México. She has published articles about medieval, modern, colonial and contemporary literature, and translations in national and foreign reviews. She is a researcher at the Institute for Bibliographical Research and teaches at the Faculty of Philosophy and Letters of the National Autonomous University of Mexico.

Julieta González Irigoyen has written four novels, two poetry books, numerous short stories and essays and spent 30 years in journalism, writing for various newspapers, including Mexicali's *La Crónica*.

Teresa González-Lee's poetry began in Chile. Her poems on digital platforms have been registered with the Library of Congress. A Spanish professor at Miracosta Community College, she served as a Regional Editor of the bilingual edition of last year's **San Diego Poetry Annual**.

Kit-Bacon Gressitt was a Pulitzer Prize-nominated political columnist at the *North County Times*. Her work appears in *The Progressive Post, San Diego Gay and Lesbian News, The OB Rag* and on Excuse-MeImWriting.com and the **San Diego Poetry Annual**. She is also founding editor of *IG Livin*, and co-founder and editor of *The Bridge*.

Diana Griggs, born in England, now living in Point Loma, works at poetry, singing and hiking. Her poems have appeared in **Magee Park Poets** and the **San Diego Poetry Annual**.

Harry Griswold grew up in New York State, where he claims life has rusted into a shell of its once prosperous self. He carries this sense of home with him. He holds an MFA from Pacific University, is the author of *Camera Obscura* (Wordcraft) and has recently published in *Argestes, California Quarterly, Gargoyle, Limestone* and *Many Mountains Moving*. He leads The Pleasures of Poetry workshop in Solana Beach.

Anita Curran Guenin was born and raised in New England. Her work has been published in *Oasis Journal, An Island of Egrets*, the 2010 *SoCal Haiku Study Group Anthology* and the **San Diego Poetry Annual**.

Sonia Gutiérrez's poetry has appeared in *City Works Journal* and *El Tecoloto* and is forthcoming in *Turtle Island to Abya Yala*. She teaches at Palomar College and is working on *Spider Woman/La Mujer Araña*. Her blog is *Chicana in the Midst.*

Malia Haines-Stewart is a student living in San Diego. Her poetry has been published in *Renaissance* (2010). This is her first appearance in the **San Diego Poetry Annual.**

Sam Hamod, nominated for a Pulitzer Prize in Poetry (1980: *Dying with the Wrong Name*), has 10 books of poems, including *Just Love Poems for You* (Ishmael Reed/Contemporary Poetry Press: 2006). He holds a PhD from the Writers Workshop of the University of Iowa and has taught at National University. He recently moved from San Diego, where he led a master poetry workshop, and now lives in Princeton, NJ. His on-line literary magazine, *Contemporary World Literature*, debuted last winter.

Kate Harding is a co-author of Maiden, Mother, Crone. Her work has appeared in *Compass Rose, Earth's Daughters, Lucidity, Spillway, Perigee* and anthologized in *Magee Parks Poets* and the **San Diego Poetry Annual**.

William Harry Harding is the publisher of the **San Diego Poetry Annual.**

Maura Harvey holds a PhD in Latin American literature from UC Irvine. *Poemas*, a collection of her works in Spanish and English, was published in Venezuela. She authored *San Dieguito Heritage*, is a founding member of the Taller del mar poetry workshop and has served on the editorial board of the California State Poetry Society since 1999.

William Hawkes makes his first appearance in the **San Diego Poetry Annual.**

Gwyn Henry's work has appeared in *Tattoo Highway, Poetry Conspiracy, Drift Wood Highway, Blue Planet, Cattle Call,* and **Artful** *Mind*. She publishes of a poetry broadside, *The Horse Might Talk*. Excerpts from her novel, *Tales for the Dolphin,* have appeared in *Lynx Eye* and the *Santa Barbara Journal*. She teaches dance at the California Center for the Arts. (gwynsdin.blogspot. com)

Gloria Hewitt makes her first appearance in the **San Diego Poetry Annual.**

Amanda Nora Igonda Hintze was born in Argentina. She studied English at the Universidad Nacional de Cuyo. She received accreditation in Spanish/English from the American Translators Association in 1986. At Mira Costa College (1998-2000) she obtained the Human Services certification Phi Theta Kappa.

Susan Hogan feels like a kitten caught in a tree. New to San Diego, she hails from Chicago, where she lived in the now-defunct Zelyonaya Maika Russian-Speaking Artists' Commune. Her poetry has appeared in *Red Shoes Review* and *The Prairie Light Review*. (susan-hogan.com)

Wayne Hosaka is native of San Diego County. Motorcycle riding was his passion before he was injured racing. This is his first appearance in the **San Diego Poetry Annual.**

Una Nichols Hynum, a finalist for James Hearst Poetry Prize, has been published in *A Year in Ink, Magee Park Anthology, Oasis Journal, The Writer's Digest, Margie* and the **San Diego Poetry Annual**.

Mario Jaime was born in La Ciudad de los Cadáveres in 1977. His poetry includes *La luz no envejece, Analemma* and *Ontología del caos*. He has also published plays, *Aloqua, demonio de la venganza* and *La guaycura fantasma*. His awards include the 2007 National Drama Prize for *Lilith*.

Curran Jeffery, born in Chicago, attended the University of Arkansas and Illinois State University, earning a degree in history and sociology, with an emphasis in religion and philosophy. He waits tables, writes poetry and leads the monthly *Sunday Sontage* reading at Bluestocking Books in Hillcrest.

Edith Jonsson-Devillers is a Regional Editor of the **San Diego Poetry Annual.**

Ilya Kaminsky is the author of the award-winning *Dancing in Odessa* (Tupelo Press: 2004). He recently co-edited *Ecco Anthology of International Poetry* (Harper Collins: 2010) and teaches at San Diego State University.

Bernard Katz, a resident of Oceanside for the past 10 years, is a retired academic who has written non-fiction books, including *Fountains of San Francisco*. He has also published short stories.

Clifton King is widely published. He lives in Carlsbad, where he spends his non-writing time in pursuit of the perfect wave.

Kayla Krut studies Comparative Literature and Creative Writing at the University of California at Berkeley. Published in *Border Voices* and *Soul Fountain*, she was awarded the Gold National Award for Poetry by the Scholastic Art and Writing Awards in 2006, 2007 and 2009. A Del Mar native, she has been published in *Cal Literary Arts*, received the Joan Lee Yang Memorial Prize in Poetry and interns for the Holloway Poetry Series.

Sharon Laabs holds a degree in music from Washington State University. She taught music in the public schools and is retired from the Birch Aquarium at Scripps. Her work has appeared in *Oasis Journal* and **the San Diego Poetry Annual.**

Christy Larson was raised in Seattle, had a life-layover in Hawaii and now resides in San Diego. This is her first appearance in the **San Diego Poetry Annual.**

Jason Lester was raised and educated in the Midwest, and is pursuing an MFA at San Diego State University. . This is his first appearance in the **San Diego Poetry Annual.**

Lenny Lianne is the author of three books of poetry, including *The Gospel According to the Seven Dwarfs* (San Francisco Bay Press). She lives in Peoria, Arizona, near the Padres spring training camp.

C.A. Lindsay hosted and produced Carlsbad Corner on KDCI. She is a member of the National League of American Pen Women and the Academy of American Poets. Here work has appeared in various literary magazines, journals and anthologies, including the **San Diego Poetry Annual.**

Fred Longworth restores vintage audio components for a living. His poems have appeared in numerous journals, including *California Quarterly, Comstock Review, Pearl, Rattapallax* and *Spillway.*

Gidi Loza was born in Torreón, Coahuila in 1985 and lives in Tijuana. She writes poetry and essays and is a graphic designer. She has worked on a collective novel project by four Mexican writers, coordinated by Elmer Mendoza.

Tomás Huitzilcohuátl Lucero's first language is Spanish. Still, while in college, he spent as much time consulting the Spanish dictionary, as he did reading *Cien Años de Soledad.* In 2009, New Directions published his first book, a co-translation: *Selected Poems: Jimmy Santiago Baca.*

Sarah B. Marsh-Rebelo was born and educated in London and traveled the world as a stewardess. After a decade in Honolulu, she moved with her son to California and obtained degrees in Gemology and Anthropology. She is currently completing an MFA in Creative Writing.

Seretta Martin is a Regional Editor of the **San Diego Poetry Annual.**

Jennifer McBroom claims to have had an uncouth mouth since grade school, but now writes surprising, sweet poems about love. She enjoys chocolate milk and loud music and lives in a house with a tire swing.

Stephen McDonald teaches at Palomar College. He attends the Sunset Poets readings. His work has appeared in *RATTLE, The Crab Creek Review, Passager, The California Quarterly* and the **San Diego Poetry Annual.**

Brad McMurrey is active in North County poetry groups and readings. He regularly competes in the La Paloma Theater poetry slam events and has been published in *Magee Park Poets Anthology.*

Hope Meek, born in 1928 in New Rochelle, NY, graduated Hood College, then spent three years in Japan and earned an MFA at SDSU and worked as assistant director at Border Voices. A black belt in Judo and a marathon canoeist, she teaches Japanese flower arranging. Her work has been published in various newspapers and magazines, including the *San Francisco Chronicle.*

In 2005, **Aida Méndez** launched the *Acanto y Laurel* (Acanthus and Laurel) binational project. She participated as a guest poet in the 2007 City College bilingual publication and took part in the bilingual documentary *Cruzando Líneas / Crossing Lines* by Brandon Cesmat and Jesús Yáñez. She is the author of the bilingual plaquette *Durante la Lluvia Sueño / During the Rain I Dream.*

Jenny Minniti-Shippey is the Managing Editor of *Poetry International* and a professor at San Diego State University. Her chapbook, *Done Dating DJs*, won the 2009 Fool For Poetry competition, from the Munster Literature Centre, Cork, Ireland. Her work has appeared in *Tar River Poetry, In Posse Review, Web Del Sol Review of Books*, and the **San Diego Poetry Annual.**

Carlos Miranda is a graphic designer born in San Salvador in 1976.

Born and raised in the San Francisco Bay area, **Carrie Moniz** resides in San Diego. A member of the San Diego Poetry Cooperative, Poetry International, and the San Diego Translation Club, her poems have appeared in *Transform This, Yellow Medicine Review, Third Wednesday, Suisun Valley Review* and *An Island of Egrets Haiku Anthology*.

Adolfo Morales Moncada, born in Mexico City in 1955, arrived in Tijuana in 1983 and began writing for newspapers, magazines and cultural weeklies. He has published three books: *Nostalgia, Nuahui Ollin* and *Boleros de papel / Paper Bolero*. For 20 years he has produced the radio program *Letras al aire / Letters to the air*.

Rodley Monk is the pen name of a novelist, filmmaker and photographer based in Los Angeles. His work has appeared on *Smithsonian World* (PBS) and in the **San Diego Poetry Annual.**

Michelle Monson's works have appeared in *Tidepools, Magee Park Poets Anthology* and the **San Diego Poetry Annual.**

Mónica Morales Rocha, born in Irapuato in 1976, lives in Tijuana. She is a university professor, photographer, poet, and co-producer and host of the radio program *Letras al aire*. Her first collection of poems *Letras des-amor-dazadas* was published in 2009.

Fred Moramarco is the founding editor of *Poetry International,* and the co-author of *Italian Pride: 101 Reasons to be Proud You're Italian, Containing Multitudes: Poetry in the US Since 1950, Modern American Poetry* and co-editor of *Men of Our Time: Male Poetry in Contemporary America.*

Daimary Moreno is from Tecate, Baja California. An actress, she has studied Hispanic-American literature and writes plays, narrative and poetry. She is Scholar of the Stimulus Program for the Creation and Artistic Development of Baja California 2010-2011, in the theater category.

Regina Morin is an original member of the *Border Voices Poetry Project* who lives in Ocean Beach. Her poems have appeared in *Visions, America, No-Street Poet's Voice, San Diego Writer's Monthly, San Diego Writers, Ink Anthology, Magee Park Poets Anthology* and the **San Diego Poetry Annual.**

Jill Moses earned her MFA in Creative Writing from the University of Oregon, where she received the graduate award in poetry and served as assistant poetry editor of *Northwest Review.* Her awards include the Allen Ginsberg Poetry Award, as well as honorable mentions through the Lane Literary Guild and the Chester H. Jones National Poetry Competition. Her poems have appeared in a variety of literary journals. She serves on the Board of California Poets in the Schools.

Vicky Nizri was born in Mexico City in 1954 and lives in San Diego. Her children's book *Un asalto mayúsculo* won the 1988 Ezra Jack Keats award. Her first novel *Vida propia* (M. A. Porrúa: 2000) was a finalist in the Quinto Premio Nacional de Novela, and her short story *Quién es otro* (El Búho: 2002) won the Premio Nacional de Literatura y Artes. Her poetic narrative, *Lilith, la otra carta de Dios* (M. A. Porrúa) came out in 2002. Her latest work, *Improbables, otros cuentos, y uno terrible,* is forthcoming.

Oriana was born in Poland and came to the United States when she was 17. Her poems, essays, book reviews and translations from modern Polish poetry have been published in *Poetry, Ploughshares, Best American Poetry 1992, Nimrod, New Letters, The Iowa Review, American Poetry Review, Black Warrior, Wisconsin Review, Prairie Schooner, Seneca Review, Spoon River Review* and *Southern Poetry Review.* A former journalist and community college instructor, she lives in Chula Vista and leads the San Diego Poetry Salon.

Rosario Orozco was born in Guadalajara, Jalisco in 1970. She holds a BA in Literature and an MA in Linguistics from the University of Guadalajara. Since 1995 she has been the director of *Va de Nuez,* a literature and arts magazine. She is the author of a poetry book: *Variaciones y alas de la sin razón.* Her work has appeared in the *a Mujeres poetas Oaxaca* anthologies.

Bibiana Padilla Maltos, from Tijuana, is closely tied to the Fluxus movement. Co-founder of two projects in experimental literature, she has published, curated, exhibited and performed since 1990. Her creative writing, experimental literature workshops and published works extend from Mexico to the U.S., Canada, Portugal, Spain, France and Cuba.

Melinda Palacio coedits *Ink Byte Magazine.* She is a 2007 PEN USA Emerging Voices Fellow and a 2009 alumnus of the Squaw Valley Community of Writers. Her chapbook *Folsom Lockdown* won the Kulupi Press 2009 Sense of Place competition. Bilingual Press will publish her debut novel *Ocotillo Dream,* in Spring 2011.

Sonata Paliulytê received the Young Jotvingis award and the Menada award from the International Poetry Festival Ditet E Naimit in Macedonia. Her second book of poems will be published this year, along with *Still Life, Selected Poems* in English. She lives in Vilnius.

Mara Pastor is a Puerto Rican poet and postgraduate student from Michigan.

Kathleen E. Peckham, aka KEP, has been a San Diego poet most of her 60 years. She has attended The Ocean Beach Poets' Circle and The LoVerne Brown Poets' Circle, as well as many local poetry readings.

Marge Piercy is one of the most celebrated writers worldwide. She leads an annual poetry workshop in Cape Cod, where she now resides, and has lectured and taught at colleges in every region of the country, including at San Diego State University. Her newest book of poems, *The Hunger Moon,*
New and Selected Poems, 1980-2010 (Knopf) came out in March, 2011. She will be the Featured Poet in next year's **San Diego Poetry Annual (2011-12).**

Quetzalli Pérez Ocampo, born in Mexicali, has lived in Ensenada since 1985. She is an active member of the Experimental Workshop of Literature coordinated by Flora Calderón. She has participated in writers' encounters in *Olas de Marzo* in Rosarito, *Horas de Junio* in Hermosillo, and *Voces del Puerto* in Ensenada. She is also a photographer.

Claudia Poquoc is a poet-teacher for California Poets In The Schools and Border Voices. Known to classroom children as Grandmother Spider of the Word Wise Web, she has several poetry chapbooks and, one song/poetry book/CD: *Becomes Her Vision.* Her poems have been published in *Oasis Journal* and the **San Diego Poetry Annual.**

Alejandra Proaño was born in Quito, Ecuador in 1976. She graduated in Psychology at the University of San Francisco de Quito and obtained her specialization in Systemic Therapies in the Pontificia Universidad Javeriana in Colombia. She also has a Master's in Technology Management and is a Master's Degree Candidate in Literature. Since 2008, she has resided in Mexico City, where she obtained a diploma in Creative Writing

Kirsten Quinn is a student at CSU-San Marcos, now continuing her writing studies abroad at Stockholm University, Sweden. Her work has appeared in *The Quarry Review* and the **San Diego Poetry Annual.**

Lisa Albright Ratnavira's work has appeared in *Poet, Bereavement, Lucidity, Limestone Circle, gaminiratnavira.com* and the **San Diego Poetry Annual**. Her chapbooks are *Traveling with Pen and Brush*, and *Maiden, Mother and Crone*. She holds an MA from Concordia University and spends her time traveling and teaching. (lratnavira@yahoo.com)

Ruth Rice is a student teacher of Ceramics at Palomar College. She has three volumes of poetry published by PoetWorks Press, where she once served as an anthology editor. Ruth has one daughter and twin granddaughters, and considers art a nutrient.

Maggi Roark makes her first appearance in the **San Diego Poetry Annual**.

Mavi Robles-Castillo is a writer, poet, cultural promoter and activist, with a degree in Communications from UABC, Tijuana. She has published two poetry books *Errabunda y Despoblada* (2010) and *Words of travel from Colombia* (2010). She is co-founder of the journal of minifiction *Magin* and of *Collective Intransigente*.

Francine Rockey is an MFA poetry student at San Diego State University. She was most recently published in the *Journal of Adolescent & Adult Literacy*.

Erin Rodoni's work appears for the first time in the **San Diego Poetry Annual**.

Alejandro Rodríguez has been a cultural promoter in the San Diego-Tijuana region for the past 25 years. As the Head of Casa de la Cultura de Tijuana he promoted an exchange between artists of both cities. As Director of the Art & Culture Institute of Tijuana, he promoted the creation of a new cultural center: El Palacio de la Cultura, in downtown Tijuana. He served as editor of *Momento Cultural* for Centro Cultural Tijuana.

Josefa Isabel Rojas Molina is a Hispanic Literature graduate of Sonora University who has been in charge of the Mexican Public Library of Cananea since 1989. She has been a teacher and coordinator at the Cananea campus of the National Pedagogic University since 1992. The author of four books of poems, she has published articles, poems and short stories in various newspapers, magazines, and anthologies.

Rae Rose's poetry and short fiction have appeared in *The Pedestal Magazine, Cicada, THEMA, Earth's Daughters, The Raleigh Review* and *Roads Poetry*. Rose was the founding editor of **The San Diego Poetry Annual.**

Marjorie Stamm Rosenfeld's poems have appeared in many publications and been anthologized in *Magee Park Poets* and the **San Diego Poetry Annual.**

Ana Rosshandler is an English professor at the State University and a translator. Her work was included in the anthology *La región menos transparente del aire*. She co-edited the literary journal *La mala mujer* and co- compiled *A sus libertades alas,* a Southern Baja California women writers' anthology.

Denise Rouffaer is a graduate of CSU-San Marcus where she majored in Human Development. Enduring the long-term effects of bacterial meningitis, she was left with learning disabilities, short-term memory issues, impaired speech and problems with her gait. Her appearance in the **San Diego Poetry Annual** marks the first time her work has been published.

John Rubio is a published author and English teacher in Encinitas. He is a frequent slam poetry performer and film enthusiast.

Alicia Salinas is a Chilean professor of literature, a writer, and a translator from the Russian, who works for the Department of Education in Santiago. She has written several books of poetry and earned various awards, including the 1994 Pablo Neruda prize.

Ron Salisbury makes his first appearance in the **San Diego Poetry Annual.**

Edmond Salus makes his first appearance in the **San Diego Poetry Annual.**

Juan Manuel Sánchez is from south San Diego and has recently returned to the area after a decade in Chicago, Indiana and Florida. His work has appeared in *Ninth Letter, Mandorla, Pembroke, The Southern Review, Palabra* and *Lana Turner.*

José J. Vázquez Sández was born in Tijuana in 1976. A poet and critic, he has published literary reviews in *Letras Libres* and *Tierra Adentro.* His poetry has appeared in *Mar Con Soroche* (Chile)*, Revista de Poesía Alamar* (Tijuana) and *Parabellum* (Spain).

Nancy Stein Sandweiss receives inspiration from the sights and sounds of daily life and tries to capture the ironies and complexities of relationships. Her poems have appeared in *Oasis Journal 2010.*

Ken Schedler: Being born in Canada between two World Wars, this poet has had various vocational tours. He recently decided to set his life to rhyme, knowing full well it won't earn him a dime.

A graduate student at San Diego State University's MFA program for Creative Writing (Poetry), **Daniela Schonberger** is a two-time recipient of the Santa Barbara Creative Writing Scholarship and a winner of the Robert Emmons Poetry Prize. She has performed her poetry all over California. Her publications credits include *The Santa Barbara Independent, Encompassing Seas,* and *A Cappella Zoo* and the **San Diego Poetry Annual.**

Kristen Scott has published in critical works *Perigee* and poetry on *Today's Alternative News, Contemporary World Literature* and the **San Diego Poetry Annual.**

R. T. Sedgwick lives in Del Mar, is a member of Harry Griswold's workshop, attended the Idyllwild Summer Arts Poetry, studied with Dr. Sam Hamod, has numerous poems in anthologies and periodicals and four poetry books: *Forgotten Woods, Harmony of a Storm, Sand Castles* and *Circles and Lines* (sedgwickARTcards).

Terry A. Severhill is a retired contractor in the Vista area with three years of college, two years in the US Marine Corps and a combat tour in Vietnam (1969-70) behind him.

A second generation Californian, nature lover and author of five non-fiction books for youth, **Jodie Shull** has worked in a variety of writing and teaching jobs. She lives in Carlsbad, writes internet copy for a publishing company and pauses frequently to look out the window.

When she moved to Carlsbad in 2003, **R. D. Skaff** returned to her writing roots, inspired by her proximity to the sea. Her work was also included in a Poets Inc. Art Summation Exhibition (2006) and has appeared in *American Pen Women Winning Poetry and Haiku, Today's Alternative News, Magee Park Poets* and the **San Diego Poetry Annual.**

Terry Spohn is a Regional Editor of the **San Diego Poetry Annual.**

Maria F. Stefanic makes her first appearance in the **San Diego Poetry Annual.**

Originally from Queens, **Carol St. John** lived in Sedona for over 25 years. With the onset of cancer, she moved to San Diego to live with her son and her grandchildren. Now cancer-free, she is writing books based on her time in what she calls "the spiritual atmosphere of Sedona."

Paul A. Szymanski lives in North County and works in downtown San Diego. His work has appeared in each edition of the **San Diego Poetry Annual.**

Daniel Charles Thomas was born near San Francisco Bay in 1950 and grew up in San Diego on the Mexican border. He studied literature, video and communications at the University of California, San Diego. In 1999, he went to Tijuana to write poetry and stayed for 10 years. He won the Frontera-Ford Binational Prize in poetry (2000) and has been published in various anthologies and reviews on both sides of the border.

Michael Lee Treadway II, 23, is a native of Escondido and holds a BA in Ancient Greek from UCLA. Currently, he is a substitute teacher for the Escondido Union High School District and teaches an after school guitar program at Orange Glen High School. He is also a walking tour guide at the San Diego Zoo Safari Park.

Bobbe Van Hise studies creative writing through Mira Costa College at the Oceanside Senior Center. Her poems have been published in *Expressions* and *Tidepools*. She taught at a center for teen-age girls in Uganda and published a journal of that experience, *How Is The Day?* She had a ministry for women at the Vista Detention Center for 10 years.

Chris Vannoy has been part of the poetry community in San Diego for 20 years, as part of Quincy Troupe's *Artists On The Cutting Edge* series, *Lollapalooza* spoken word tent, California Poets In The School's *Border Voices*, a poetry exchange between southern California poets (*Tearing The Curtain 3*) and he was part of the first team to represent San Diego at the National Poetry Slam. He participated in *Sparring with the Beatnic Ghosts* at The Beat Museum in San Francisco.

Terry Ventura is a library assistant and Monographs Cataloging Coordinator at the University of San Diego. Her hobbies include her cats, travel, yoga, weight lifting, scuba diving and attending lectures.

John (Jack) Webb is a retired newspaper editor and founder-director of the Border Voices Poetry Project (bordervoices.com). In 2008, he was named to the Governor's panel to choose the state poet laureate. He won awards for his journalistic investigations of the Hell's Angel motorcycle gang and the Mexican Mafia, as well as his interviews with Ronald Reagan and Muhammad Ali and served as assistant bureau chief at the Sacramento bureau of Copley News Service. He was the poetry editor of *San Diego Writers' Monthly*. His essay on poetic wisdom and its relationship to spiritual and mental health appeared in *San Diego Physician* magazine.

Megan Webster is a Regional Editor of the **San Diego Poetry Annual.**

Jon Wesick is a Regional Editor of the **San Diego Poetry Annual.**

Michael Cheno Wickert, poet, father, husband, writer, Southwestern College professor, writes about *los otros y las otras*, lives in Chula Vista between two freeways and bike-rides all the way to Coronado Bay and back, *de vez en cuando.*

Elizabeth Yahn Williams prefers performing poetic dramas to practicing law. She has done mentoring work, has written, directed and hosted a local TV mini-series that won a Telly Finalist's Award and co-edits *Summation: A Merging of Art and Poetry* a San Diego Book Award finalist, for Escondido's Municipal Art Gallery and Poets INC. A member of the Publishers and Writers of San Diego and the National League of American Pen Women, her chapbook is *Seasonal Reflections.* With her Partner-in-Rhyme, Bob Lundy, she emcees Oceanside Public Library's National Authors' Day. (hitherandyahn.com)

Gary Winters is the author of The Deer Dancer (Sunbelt Publications). He won the Mensa International Journal's mid-centennial poetry contest and has had work published in *Poems of Romance & A Year in Ink, Literary Liftoff, Lucidity, Your Royalty Note, The Writer's Life, Everyday Musings, Wordgathering*, and *Poetry Motel*. His chapbook, *Cigarette girl*, was a finalist in the San Diego Book Awards 2008, the same year Boyne Berries in Ireland published his *The Lion's Tooth*.

Ellen K. Wolfe, a Carslbad-based writer who works in business, has been a news and magazine writer, including work for the Associated Press in the Pacific Northwest and Alaska. She is working on an MFA in Poetry with Pacific University.

Carmela Zermeno was born in San Clemente and moved to Vista when she was five. She graduated from CSU-San Marcos with a BA in Literature and Writing.

Al Zolynas is the author of three books of poetry: *The New Physics, Under Ideal Conditions* and *The Same Air*. With Fred Moramarco, he co-edits two anthologies, *Men of Our Time* and *The Poetry of Men's Lives*.

Diantha L. Zschoche is an African-American who has been writing poetry since high school, but has only sought publication in the last several years. Her work has appeared in *Magee Park Poets Anthology*, the 2008 *Summations Journal* and the **San Diego Poetry Annual**.

FEATURED POET

Steve Kowit was born in Brooklyn in 1938. He is the author of several books of poetry and has published a guide to writing poetry: *In the Palm of Your Hand*. His work has been published internationally in a wide variety of literary magazines, journals and anthologies, including *The New Yorker* and the **San Diego Poetry Annual.**

All four of his poems in this 2010-11 edition are new and previously unpublished.

His awards include a National Endowment Fellowship in Poetry, two Pushcart Prizes, the *Atlanta Review* Poetry Prize, the Ouroboros Book Award, the 2006 *Tampa Review* Poetry Prize, and most recently the San Diego Theodore Geisel Award. His collection of poems, *The Dumbbell Nebula*, was a *San Francisco Chronicle's* Notable Book of the Year.

He received a BA from Brooklyn College, a MA from San Francisco State College, a MFA from Warren Wilson College and studied with Robert Lowell and Stanley Kunitz. In 2009, he became the poetry editor of *Perigee*. He teaches at Southwestern College in Chula Vista and lives in Potrero near the Tecate Mexican border.

REGIONAL EDITORS

Brandon Cesmat is a professor at the California State University at San Marcos. His books of poems include *When Pigs Fall in Love* and *Light in All Directions*. His has contributed to many literary magazines, journals and anthologies nationwide, including the **San Diego Poetry Annual.**

Olga García's work has been published in anthologies in the U.S., Mexico, Spain and Venezuela. She has written three books of poetry in English and two in Spanish. She is an Advisory Board member of San Diego Writer's Ink. (poetolga@yahoo.com)

Edith Jonsson-Devillers, a PhD in Comparative Literature, with a major in contemporary poetry, taught French, English and Spanish languages and literatures on campuses in Europe and the U.S. She founded and directed two language schools and a translation company, while working as a court interpreter and doing simultaneous interpretation in international conferences. She has prepared and edited textbooks for major publishing companies, and published six books of translations from or into French, English and Spanish, as well as various articles and poems in anthologies. She enjoys playing Indian tabla and dancing.

Seretta Martin is the author-artist of *Foreign Dust Familiar Rain* and several chap books (Blue Vortex). She serves on the editorial staff for *Poetry International Journal*, hosts the Barnes and Noble Poetry Series in La Mesa, is a founding member of

the new Haiku San Diego and teaches workshops for **Border Voices** Poetry Project and California Poets in the Schools. This year she will serve as poetry judge for Saint Marks Religious Art Festival. Her work has appeared in **Web del Sol, Margie, A Year in Ink, Oberon Foundation, Oasis Journal, Tidepools** and the **San Diego Poetry Annual.** (web.mac.com/serettamatin) (bordervoices.com) (cpits.org)

Robt O'Sullivan Schleith co-hosts a monthly Poets INC (Inland North County) reading at the Escondido Municipal Gallery (poetryscenestealers.tripod.com). He publishes under the family names of his mother and step-father, to honor both with his writing. He has contributed to a wide variety of literary magazines, journals and anthologies, including the **San Diego Poetry Annual.**

Terry Spohn has an MFA from the Writer's Workshop at the University of Iowa and lives with his wife, Dionne, in Escondido, where he is not quite retired. His short fiction, prose poems and poetry have appeared in *Ascent, Grub Street, Mississippi Review, North American Review, Oyster Boy Quarterly, Eclectica,* and other small magazines and his poems have appeared in four anthologies.

Megan Webster, a multiple transplant of Welsh origin, is an ESL teacher, poet, and freelance editor and translator. Her poems have appeared in previous editions of the **San Diego Poetry Annual.** Her chapbook, *Bipolar Express* (inspired by experiences with bipolar disorder), received a San Diego Book Award. (MWeb5089@ aol.com)

Jon Wesick holds a PhD in physics has studied Buddhism for 20 years and has been widely published in literary magazines, journals and anthologies, including *Pearl, Slipstream, Iconoclast, Edgz, Tidepools, **Magee Park Poets Anthology*** and the **San Diego Poetry Annual**. His chapbooks have been finalists in the San Diego Book Awards and his poem *Bread and Circuses* finished second in the 2007 African American Writers and Artists contest.

PUBLISHER

William Harry Harding has written three novels, all from Holt, Rinehart & Winston: *Rainbow* (1979; Book-of-the-Month Club featured alternate), *Young Hart* (1982; winner of the New Jersey Writer's Award of Merit) and *Mill Song* (1985; excerpted in the anthology *Italian American Writers of New Jersey* [Rutgers University Press: 2003]). His children's book, *Alvin's Famous No-Horse* (Henry Holt: 1992), illustrated by Michael Chesworth, has been translated into six languages.

He served as Book Critic for *Westways* (1980-90), contributed literary criticism to the *Los Angeles Times* and worked as Sports Editor of *The Californian* (1986-91).

A former president of the Vallecitos School District govering board and a board member and former president of the Rainbow Property Owners Association, he edits *The Rainbow News*, a quarterly chronicle of life in Rainbow, now in its 18th year of uninterrupted publication. (rainbowca.com)

President and Chairman of the Board of the non-profit San Diego Entertainment and Arts Guild (sdeag.org), he is a member of ASCAP, the Writer's Guild of America, West and The Author's Guild.

Under the stage name Franco Z, he leads a local jazz band, **Z-BOP!**, at venues throughout Southern California. (lodestarz.com)

He came to San Diego in 1969 to fly fighters for the U.S. Navy, completing over 200 combat mission aboard the aircraft carriers *USS America* and *USS Constellation*.

Acknowledgments

Celebratory readings for the **San Diego Poetry Annual 2009-2010** were generously hosted by:

Cultural Center for La Raza
2004 Park Blvd
San Diego, CA 92101
(619) 235-6135
centroculturaldelaraza.org

Escondido Municipal Arts Partnership Gallery
262 E. Grand Ave.
Escondido, CA 92025
ph. (760) 480-4101
escondidoarts.org

Southwestern College
900 Otay Lakes Road,
Chula Vista, CA 91910
(619) 421-6700
swccd.edu

Bluestocking Books
3817 Fifth Avenue
San Diego, CA 92103
(619) 296-1424
blustockingbooks.com

MIRAMONTE WINERY – 33410 Rancho California Rd., Temecula, CA 92591 (951) 506-5500 – generously provided two cases of wine served at the readings.

Special thanks to **Eddie Rodriguez (DJ Satchamo), San Diego Entertainment and Arts Guild, Robt O'Sullivan Schleith, Francisco Bustos, Teresa González-Lee** and **Curran Jeffery** for organizing and staging the readings.

End Notes

Cover Art: *Big Surf* at Ocean Beach Pier, January, 2011 – photograph by Taax.

Typeface: Palatino Linotype is used throughout, except for display type of the title. Following a policy to keep an entire poem intact if it would fit on one page, type size and font are occasionally altered.

Payment: No one connected with the **San Diego Poetry Annual** receives payment of any kind.

Copies: Instead of the customary practice of providing contributors with free copies, copies of the **San Diego Poetry Annual** are donated in the name of the contributing poets to every college and university library in San Diego County, to the San Diego County and City library systems and branches, to libraries of independent cities in the county and to select libraries nationally.

In accordance with an agreement between the Publisher and printer, copies are made available to contributors at a special rate. Garden Oak Press makes no profit on these sales to contributors.

Copies are offered for sale through the auspices of the San Diego Entertainment and Arts Guild, a non-profit organization. Accordingly, all copies purchased qualify as tax-deductible donations.